The Campus History Series

SYRACUSE
UNIVERSITY

The Campus History Series

SYRACUSE UNIVERSITY

EDWARD L. GALVIN, MARGARET A. MASON,
AND MARY M. O'BRIEN

Go Orange!

Margaret Mason

Ed Galvin

Mary O'Brien

ARCADIA
PUBLISHING

Published by Arcadia Publishing
Charleston, South Carolina

Printed in the United States of America

Library of Congress Catalog Card Number: 2012955377

For all general information, please contact Arcadia Publishing:
Telephone 843-853-2070
Fax 843-853-0044
E-mail sales@arcadiapublishing.com
For customer service and orders:
Toll-Free 1-888-313-2665

Visit us on the Internet at www.arcadiapublishing.com

With sincere gratitude, we dedicate this book to all those who took out their cameras and forever captured moments in the history of Syracuse University.

CONTENTS

ACKNOWLEDGMENTS

From the moment we decided to take on this project, the Syracuse University administration embraced the concept of this photographic history of the university. Chancellor Nancy Cantor and Assistant Chancellor Trudy Morritz provided the green light to proceed. Our colleagues in the University Bookstore, Office of Marketing and Communications, and elsewhere offered encouragement and assistance along the way.

The Syracuse University Archives has a strong relationship with the Syracuse University Photo and Imaging Center, whose older images are housed in the archives. Therefore, many of the images used in this book, although now part of the archives' image collections, were in fact taken by staff from the center over the last half century. We want to publicly thank our friend and colleague Stephen Sartori, the center's director, for the fine images he has taken that appear throughout the later chapters of this book.

We always say that we could not accomplish what we do in the archives without our valued student employees. They spent hours scanning and organizing hundreds of photographs for this book. Thank you, Meghan Durling, Kendra Okereke, and Holly Stone.

Finally, we want to thank our Archives and Records Management colleagues for their patience, understanding, and support over the last few months as we postponed some projects and spent so much time huddled together in meetings. Thank you, Cara Howe, Susan Hughes, Larry Mead, and Kathleen Pieri—we could not have done this without you.

Unless otherwise noted, images appear courtesy of the Syracuse University Archives or the Syracuse University Photo and Imaging Center. Some photographs housed in the archives include the photographer's name. Where appropriate, this information is provided in the image caption.

INTRODUCTION

Syracuse University began as the vision of members of the Methodist Episcopal Church to establish an institution of higher education in Syracuse, New York. In this proposed university, "Christian learning, Literature, and Science in their various departments, and the knowledge of the learned professions shall be taught." Ties to the Methodist Church may have ended in the early part of the 20th century, but the values remain.

Syracuse University was officially chartered on March 24, 1870, as a private, coeducational institution of higher education offering programs in the physical sciences and modern languages. Having begun with only one college, the College of Liberal Arts, and a modest class of just 41 male and female students in rented space in downtown Syracuse, the university is now an expansive campus situated on a hill east of the city in central New York. Syracuse University is comprised of 13 schools and colleges and has an enrollment of over 21,000 students, representing all 50 US states and 126 countries.

As staff members of the Syracuse University Archives, we considered ourselves to be the logical candidates to take on the challenge of compiling this pictorial history of Syracuse University. After all, the archives holds a vast collection of visual materials, estimated at over 750,000 individual items, ranging from early lantern slides to current digital images. The items include prints, negatives, contact sheets, slides, photograph albums, and postcards. In addition, items are held in collections of departments, faculty, and alumni. We recognized that the task of identifying representative images from 143 years of history and writing about them would be herculean. However, we agreed to accept this project as part of our department's work.

The 200-plus images in this book reflect the perspectives of three individual archivists, each with his or her own knowledge and viewpoint of what should be included. Located images were easily divided into several areas: chancellors, schools and colleges, campus buildings, athletics, major events, and student life and traditions. Each of these themes has been integral to the history of the university. Our chancellors, schools, and colleges tell Syracuse's story from various administrative and academic points of view. The university's academic and athletic achievements also have places in its history. The construction and, sometimes, demolition of buildings on the campus have given a physical shape to the university's narrative. Syracuse has been affected not only by international and national historic events but also local experiences that are made profound within the larger context of American history. Syracuse University's students have been the lifeblood of campus life. Their work, their play, the organizations in which they take part, and the traditions and beliefs they have upheld have together played a key part in the university's past and present.

The first chapter, "Knowledge Crowns Those Who Seek Her," highlights the founding of the university and the move to its current location in 1873 with the opening of the first campus building, the Hall of Languages. Slow but steady growth is evident with the addition of new colleges and the construction of other iconic buildings, such as Crouse College and Holden Observatory.

The second chapter, "Flag We Love! Orange!," covers a period of tremendous growth. Several more schools and colleges were added, and the university's building program was enhanced until, by the 1920s, there were 28 buildings on campus. Much of this growth was due to philanthropist John Dustin Archbold, head of Standard Oil and chair of the Syracuse University Board of Trustees. Archbold donated enough funds to keep the university afloat in hard times. The 1920s and 1930s, as seen in chapter three, "A Forward-Looking University," was a time of fluctuation between the prosperous days after World War I and a plunge into the Great Depression at the end of the 1920s. Growth may have been slow, but it was a time of international outreach, the founding of the Maxwell School, and the building of the interdenominational Hendricks Chapel.

Arguably, it was World War II that changed the fortunes and focus of Syracuse University and provided national exposure. As chapter four, "A Victory University," notes, the university was opened to specialized training for thousands of soldiers, sailors, and nurses. The university promised anyone entering the service that there would be a place waiting for them at Syracuse when they returned, and it has been said that, by the close of the war, no university in the country was more closely identified with the GI Bill than Syracuse. This period also highlights Syracuse's push to offer more than just "adequate classroom facilities and ivy-covered buildings" and to expand its academic standing and institutional research capabilities.

The fifth chapter, "An Open Institution," shows how Syracuse University was able to maintain its status as an institution accessible and receptive to all during the turbulent 1960s and 1970s. Coeducational from the beginning and with a long history of diversity, the university faced the challenges of student unrest and demands for equality and was still able to evolve during this period of change.

Chapter six, "Excellence Achieved," covers the last decades of the 20th century. It is the period of the demise of Archbold Stadium and the rise of the Carrier Dome. Sadly, it is also a time of pain. The 1988 bombing of Pan Am Flight 103 took the lives of 35 students studying abroad with Syracuse University. The final chapter, "The Soul of Syracuse University," brings us to the present. Chancellor Nancy Cantor's charge to the university community is "Scholarship in Action," a commitment to forge bold, imaginative, reciprocal, and sustained engagements with our many constituent communities, local as well as global.

Syracuse University is not an all-inclusive history, as limitations in size and format make that impossible. Unfortunate, too, is the fact that some early events in the history of the university were never recorded in photographs. However, those interested in more images of the university's rich history are invited to visit the University Archives or enjoy the archives' website (archives.syr.edu), where photographic images are on permanent display. The images in *Syracuse University* hopefully capture the essence and spirit of a university that offers a rich mix of academics, student activities, and engagement opportunities on campus and around the globe. As it looks toward its 150th anniversary in 2020, Syracuse University remains an integral component of central New York.

One

KNOWLEDGE CROWNS
THOSE WHO SEEK HER

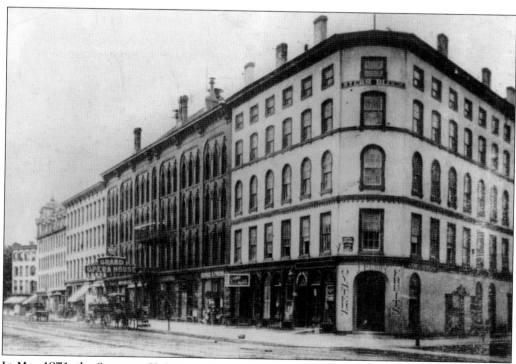

In May 1871, the Syracuse University Board of Trustees Executive Committee agreed to rent space downtown in the Myers Block for Syracuse University classes and offices. On September 1, some 41 students attended the university's opening, officiated by Dr. Daniel Steele, vice president of the College of Liberal Arts. Classes continued in the Myers Block until the Hall of Languages was finished in 1873.

A Methodist Episcopal bishop, Jesse Truesdell Peck (1811–1883) was a founding father of Syracuse University. In 1870, Peck and three others each donated $25,000 to start the institution. He served as president of the board of trustees (1870–1873) and was a member until his death. Peck Hall was named for him, as is the Peck Professorship of Literature in the College of Arts and Sciences.

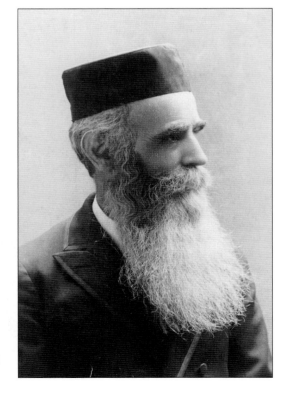

In 1873, Syracuse University founded the College of Fine Arts, the first four-year, degree-granting college of fine arts in the nation. George F. Comfort (1833–1910) was the founding dean. He also helped establish the Metropolitan Museum of Art. Offering degrees in architecture, art, and music, the college continued under that name until the mid-20th century, eventually becoming the College of Visual and Performing Arts.

Alexander Winchell (1824–1891) was appointed the first chancellor of Syracuse University in 1872. Previously a geology and zoology professor at the University of Michigan, he was inaugurated in February 1873. He oversaw the founding of the College of Medicine and the College of Fine Arts and the construction of the Hall of Languages. Winchell resigned in June 1874, after the Panic of 1873, which brought financial hardship to the university.

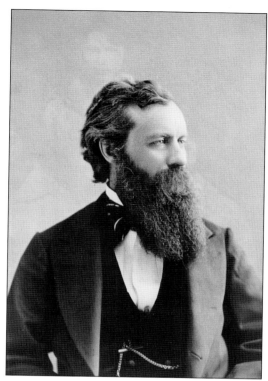

This stereopticon slide, dated 1872 or 1873, is the earliest known image of the Hall of Languages, Syracuse University's first building on campus. Designed by Horatio Nelson White, the building cost $136,000. The cornerstone was laid in August 1871; by May 1873, the Hall of Languages was dedicated and in use. Initially home to the College of Liberal Arts, the edifice has since housed other schools and departments.

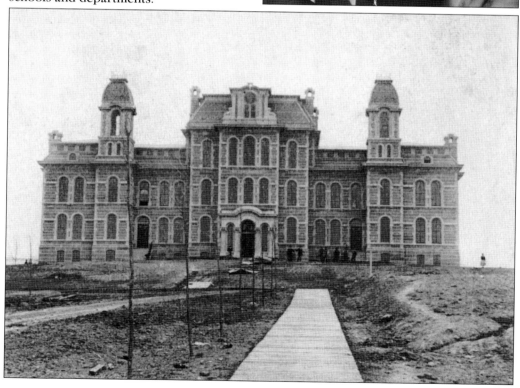

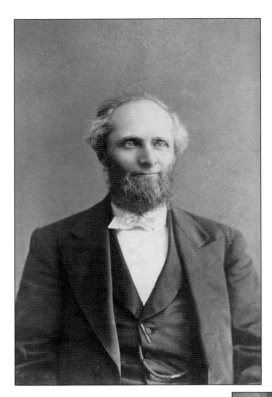

Erastus O. Haven (1820–1881) succeeded Winchell as chancellor of Syracuse University in 1874. Haven had previously served as president of the University of Michigan and Northwestern University. Syracuse University's financial burdens left Haven little room to improve it organizationally; instead, he focused his energies on strengthening both the curriculum and the university's relationship to the city of Syracuse. In 1880, Haven left Syracuse University to become a Methodist Episcopal bishop.

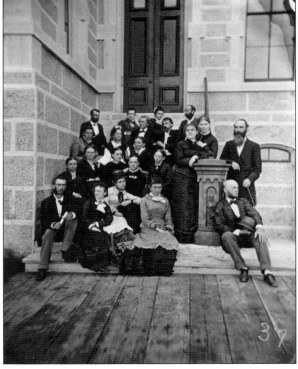

Class of 1876 graduates and professors pose on the steps of the Hall of Languages, at that time the only building on campus. These students are part of Syracuse University's fifth graduating class, numbering 53, who had attended either the College of Liberal Arts, the College of Fine Arts, or the College of Physicians and Surgeons. They became teachers, physicians, clergymen, newspaper editors, and lawyers throughout the United States.

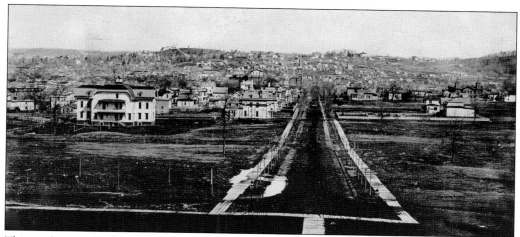

This early view looking north from campus down University Avenue shows the growth on the hill after Syracuse University built the Hall of Languages in 1873. Note the wooden plank sidewalks. The large building on the left is the Hospital of the Good Shepherd on Marshall Street. Enlarged several times, it is now part of the university and known as Huntington Hall.

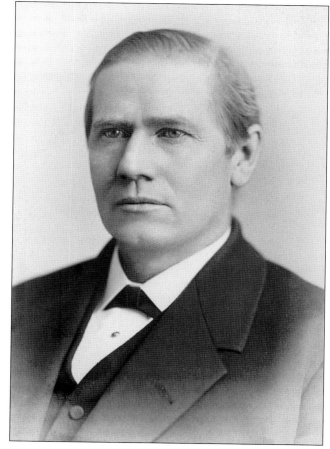

An educator, administrator, and minister, Charles N. Sims (1835–1908) was inaugurated as chancellor on June 28, 1881. During his tenure, the university charter was amended to establish the university senate, reorganize the board of trustees, and create a separate fund for endowments. Sims also established a building program, which included Holden Observatory and Crouse College. He retired in 1893, but was made a university trustee in 1903.

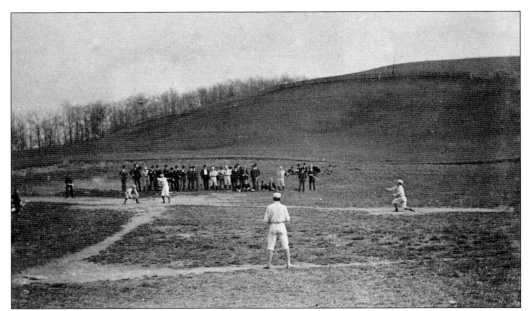

Informal games played among students led to the formation of the Syracuse University Baseball Association on April 20, 1872, preceding the Athletic Association of Syracuse University by four years. While many games were played on whatever flat land was available, the baseball association pushed for the construction of a diamond on the campus. Here, a game takes place below the hill of Mount Olympus.

Students did not reside on campus until the first dormitory was built in 1900. Until then, they lived in fraternity or sorority houses, rented a room in boardinghouses or other residences in the city of Syracuse, or resided with their families. Howard D. Mitchell (class of 1887) posed with his fellow housemates at his boardinghouse. He is probably one of the two young men in the front row.

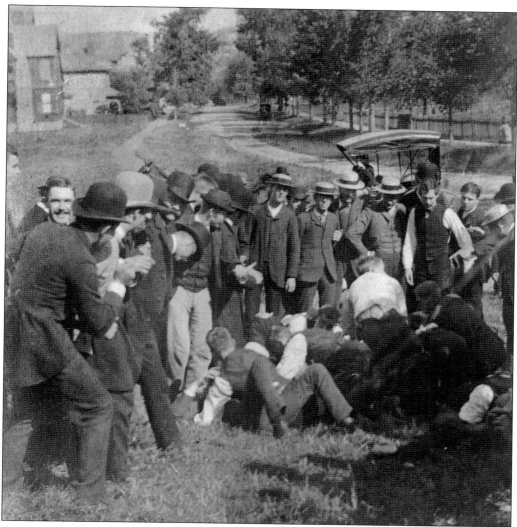

Competitions between freshman and sophomore classes were the source of many traditions at Syracuse University. The tradition of the "rush" first emerged when sophomores began to throw salt at the freshmen and even rub it into their hair. The ritual then evolved into the second-year students thumping the freshmen with bags of salt. This then developed into sophomores defending Crouse College Hill against charging freshmen, whose object was to reach the summit. After a while, many different rushes were occurring on campus—Flour, Salt, Snow, Cane, and Orange—but the Salt and Flour Rushes were the most popular. World War I put the tradition on hold, but by the 1940s, it appears to have stopped altogether, especially after a sophomore was injured in a 1941 rush. In this 1885 photograph, sophomores and freshmen wallop each other with canes.

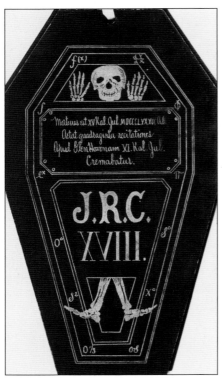

Liberal arts sophomores had to take calculus, a course most students loathed. At the school year's end, they gathered to ceremonially "dispose of" the character Calculus, a tradition dating from 1873. Housed in a coffin, he met his demise through burial on Crouse College Hill, cremation, balloon air launch, or watery grave. Shown here is the 1889 program for the cremation of John R. Calculus ("JRC") in Glen Haven, near Skaneateles Lake.

In 1887, Syracuse University trustee Erastus F. Holden donated the cost of the university's second building in memory of his son, Charles Demarest Holden (class of 1877). Holden Observatory, designed by Archimedes Russell and constructed of Onondaga limestone, housed an eight-inch Alvin Clark telescope, three-inch reversible transit, a comet seeker, chronograph, and chronometer. In 1980, Holden Observatory was placed in the National Register of Historic Places.

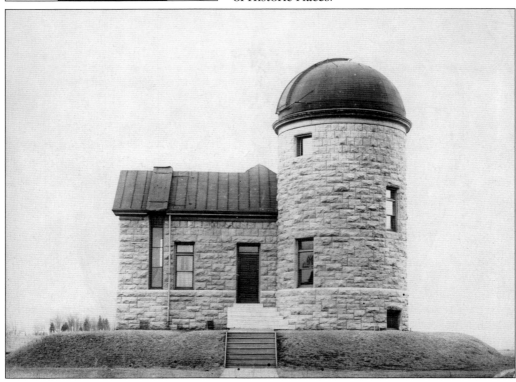

Members of the Men's Glee Club pose on porch steps in the mid-1880s. The club performed with others, such as the Banjo and Mandolin Club, piano soloists, and readers, in concerts held in Crouse College or other Syracuse venues. In the 19th century, Syracuse University students enriched their academic life by participating in athletics and other activities such as drama, newspapers, debates, and music, and by attending concerts and lectures.

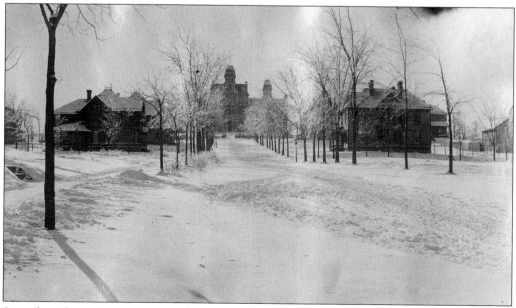

Snow has always been an integral part of Syracuse University campus life. This photograph, which dates from 1886–1887, shows University Avenue leading to the Hall of Languages on the crest of the hill. Houses continued to be built along the main thoroughfare to campus, both as homes for faculty as well as boardinghouses for students.

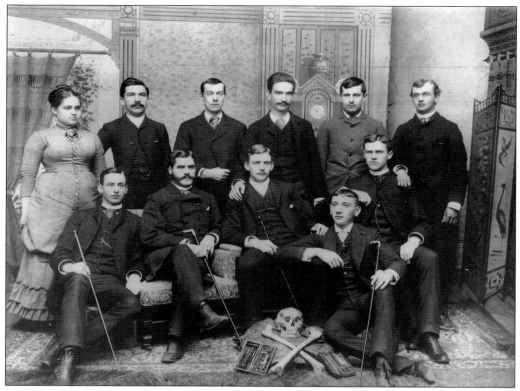

In 1872, Geneva Medical College transferred to Syracuse and became the second college of the university. This affirmed Syracuse University's intent to be comprehensive and to add colleges as resources permitted. The College of Medicine remained with Syracuse until it was sold to New York State in 1950. Shown here are members of the class of 1887. (Courtesy of the Department of Historical Collections, Health Sciences Library, SUNY Upstate Medical University.)

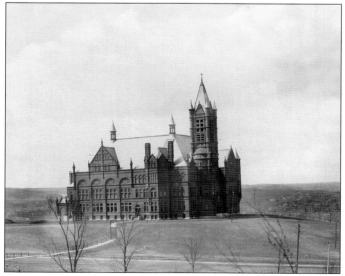

Crouse College, designed by Archimedes Russell in Romanesque Revival style, was financed in 1889 by university trustee John Crouse as a home for the College of Fine Arts. The interior includes a carved wooden staircase, a 700-seat auditorium, stained-glass windows, an organ, and a bell tower that houses the first bell tower chimes in Syracuse. Crouse College was placed in the National Register of Historic Places in 1974.

The von Ranke Library was built in 1889 to house the newly purchased collection of German historian Leopold von Ranke. The west wing was added in 1903. Library holdings were transferred to Carnegie Library in 1907, and von Ranke became the Administration Building. It was rededicated as the William Tolley Administration Building in 1985, and became the Tolley Humanities Building after administrative offices were relocated in 2010.

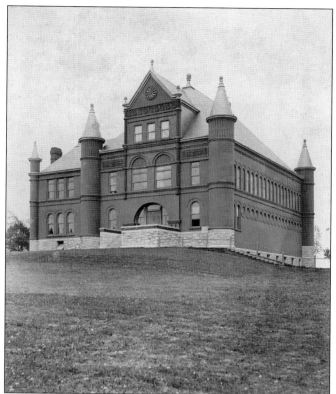

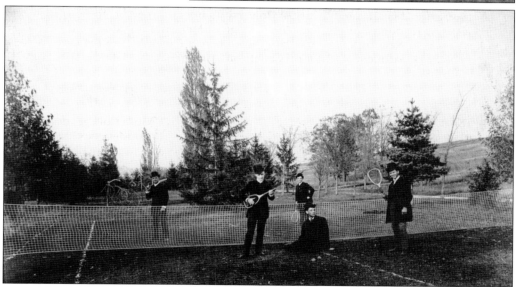

Brothers of Delta Kappa Epsilon play tennis in Walnut Park above Marshall Street in the fall of 1887. This fraternity was the first at Syracuse University; the Phi Gamma chapter of Delta Kappa Epsilon was chartered in November 1871. The fraternity was prominent in campus traditions and activities—members rang the chimes in Crouse College and published the student paper, the *Syracusan*.

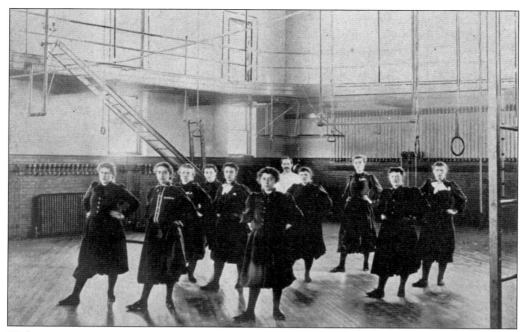

With a new gymnasium completed by January 1892, all students were required to undergo medical examinations and, unless excused, were to attend classes in physical training. As illustrated by this 1895 women's battleball class, female athletes were proud about their prowess on the court. "Vigorously do we practice . . . and so expert have we become that we quite belie the accusation that a girl can't throw a ball."

The Athletic Association of Syracuse University, established in 1876, was instrumental in the promotion of "Field Days." These informal track-and-field contests were open to any student who wished to participate. The competition included races—hurdles, dash, relay, and long-distance—tug-of-war, jumping, walking, and the hammer throw. Here, participants practice for the relay race on campus in the late 1800s.

In an effort to hold all campus athletic events on the Hill, a rough track was laid out in 1887 and underwent improvements in the 1890s. This area, south of the Hall of Languages, was the Oval. It was used for football, baseball, track-and-field events, and, eventually, lacrosse. The university's first gymnasium was included within the Oval's boundaries, creating a modest sports complex of its time.

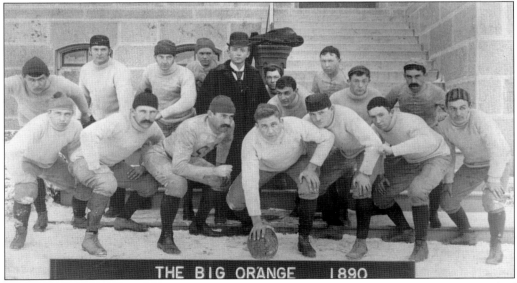

THE BIG ORANGE 1890

Syracuse University football officially began in October 1889. That first season consisted of a practice game (won) and one official game (lost). However, the 1890 season had better results—eight wins and three losses. The *Syracusan* reported: "Interest taken in college football unprecedented in any other college sport, and that of the people of Syracuse itself, which increases with every game and the future of football in Syracuse seems to be assured."

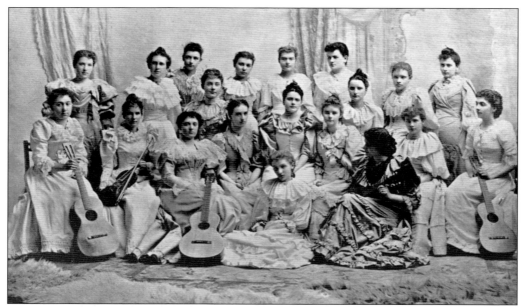

Syracuse University was coeducational from the start, and female students participated fully in campus life. A college education was not typical for 19th-century women, so these members of the Ladies Glee and Guitar Club in 1895 were remarkable and accomplished students. Many went on to earn graduate degrees. Classes as well as clubs and activities were mixed-gender, but there were women-only groups, such as the glee club and sororities.

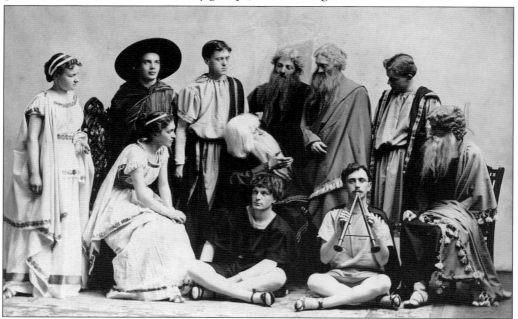

Members of the Classical Club pose dressed in elaborate costume for their performance of the Latin play *The Trinummus of Plautus* in 1895. The club was formed in the mid-1890s for those who were interested in classical studies. The organization was open not only to female and male students, but to Latin and Greek professors as well.

Two

FLAG WE LOVE! ORANGE!

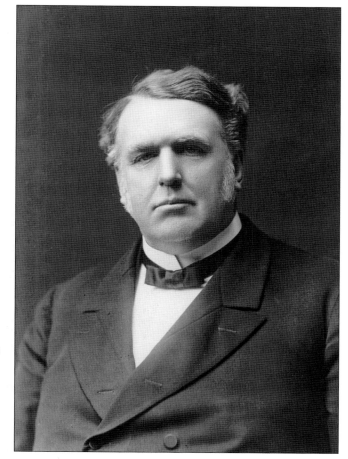

James Roscoe Day (1845–1923) was the university's longest-tenured chancellor, serving from 1894 to 1922. Stating "I see in my mind's eye a great university on the Hill," Day contributed more to Syracuse University's growth than any other chancellor. His administration oversaw the erection or purchase of 22 buildings and established 13 new divisions and schools. By the time he retired, enrollment had increased from 777 to 6,422 students.

"Flag we love! Orange!," wrote Junius Stevens, class of 1895 and author of Syracuse University's "Alma Mater." Though Stevens's handwriting appears scribbled and the paper has darkened with age, this document is precious to the university. The alma mater was first sung in public on March 15, 1893, by the University Glee and Banjo Club in a concert at the Wieting Opera House in Syracuse. They sang: "Where the vale of Onondaga\ Meets the eastern sky\ Proudly stands our Alma Mater\ On her hilltop high.\ Flag we love! Orange! Float for aye-\ Old Syracuse, o'er thee,\ May thy sons be leal and loyal\ To thy memory." The line "May thy sons be leal and loyal" was changed in the spring of 1986 to "Loyal be thy sons and daughters" to be more inclusive and to reflect that Syracuse University has always been coeducational.

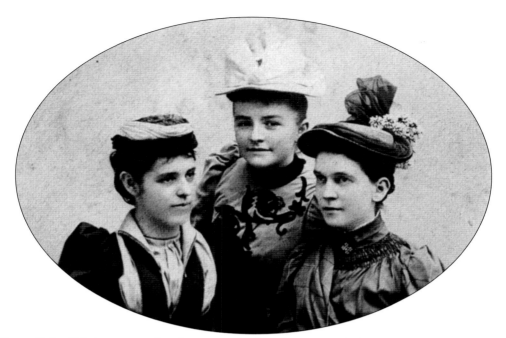

Three Alpha Phi sisters pose for the camera in the 1890s. Founded in 1872, Alpha Phi was the first women's fraternity at Syracuse University. The Alpha chapter, made up of 10 of the 20 women attending the university, also established the first house for a women's Greek letter organization in 1887. Greek life combined sisterhood with the academic and philanthropic ideals of the 19th-century female student.

Although Chancellor Winchell appointed a committee in 1873 to consider founding a College of Law, one was not established at Syracuse University until September 1895. Originally a two-year course of study, the college was housed in several locations in downtown Syracuse until the 1950s. Shown here are members of the class of 1918 on the steps of the college's third home, the former John Crouse residence on Fayette Street.

Built through private contributions, the College of Medicine building opened in October 1896 on Orange Street (later McBride Street) in downtown Syracuse. In 1937, when the Medical College on Irving Avenue replaced it, the School of Extension Teaching and Adult Education (later University College) moved in. On March 30, 1958, the building was renamed Jesse T. Peck Hall, in honor of one of the founders and trustees of Syracuse University.

On January 9, 1898, the first "regular game" of Syracuse University women's basketball was played between the classes of 1900 and 1901. With local enthusiasm high, on March 31, 1898, a Women's Basket Ball Association was formed. Syracuse women also played city teams as well as Cornell University, Elmira College, and Barnard College. Therefore, the first intercollegiate basketball competition at Syracuse University was a woman's sport.

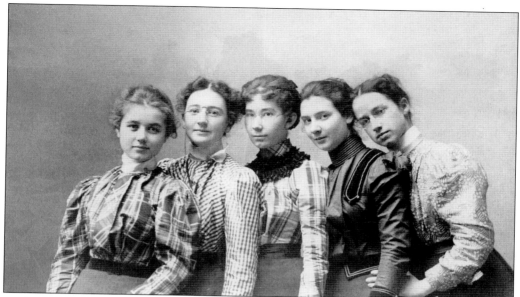

In the 1890s, as a means to provide more staffing for the library, the first course in library economics was offered. It required students to devote time to library work. Certificates were awarded to women students, such as these young women posing in 1900. A library school was established in 1908 as part of the College of Liberal Arts, but it became a separate School of Library Science in 1915.

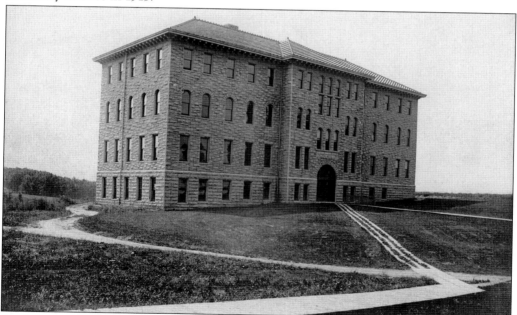

Steele Hall was funded by a gift of Esther Baker Steele and other Syracuse University trustees. First occupied in 1898, it originally held the physics department. Designed by architect Edwin Gaggin (class of 1892), it is constructed of rock-faced Onondaga limestone and built in the modified Renaissance style, to match Holden Observatory. Over the years, Steele Hall has housed many other departments and is now an administration building.

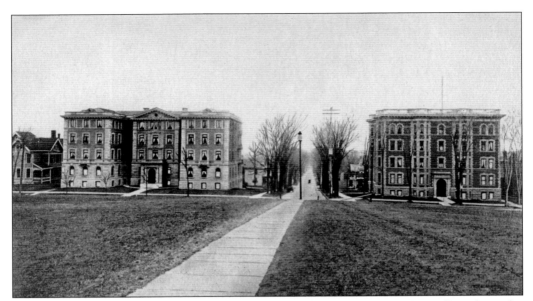

In 1900, Winchell Hall (right) was named after Syracuse University's first chancellor, Alexander Winchell. Designed by Edwin Gaggin in the modified Renaissance style, it was the first dormitory on campus. The Italian Renaissance–styled Haven Hall (1904) was named for Syracuse University's second chancellor, Erastus O. Haven. Designed by Professors Revels and Hallenbeck, Syracuse University's second dormitory was situated across University Avenue from Winchell. Both dorms were exclusively for women.

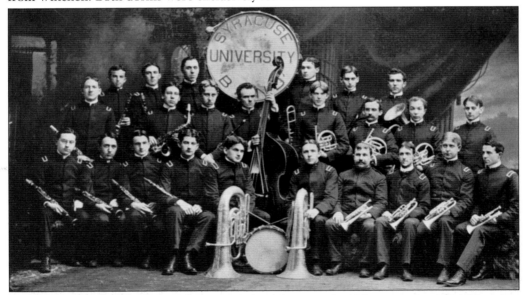

Founded at the turn of the 20th century, the University Band became the official band at Syracuse University functions. Instructed by a music professor, the students performed at athletic, social, and religious events on campus and also gave concerts. Financial contributions from faculty, students, and alumni allowed them to purchase uniforms, music, and instruments. This precursor to the marching band was a men's-only organization; women students participated in instrumental clubs.

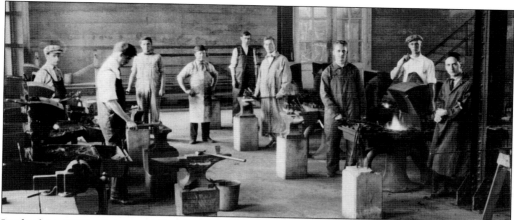

In the late 1890s, Lyman C. Smith, Syracuse University trustee and owner of the nationally known Smith Typewriter Company, found that his business was suffering from a lack of trained toolmakers and mechanics. In 1900, he announced his intention of erecting a building with all the necessary equipment for the promotion of mechanical engineering. That building opened in 1902 as the Hall of Engineering, pictured below and now known as Smith Hall. In response to his generosity, his fellow trustees immediately established the Lyman C. Smith College of Applied Science. The college offered degrees in civil, electrical, mechanical, industrial, and chemical engineering, as well as courses in business management, economic organization, and control of large enterprises. In the above photograph, students are learning blacksmithing in the shop in the basement of the second engineering building, Machinery Hall.

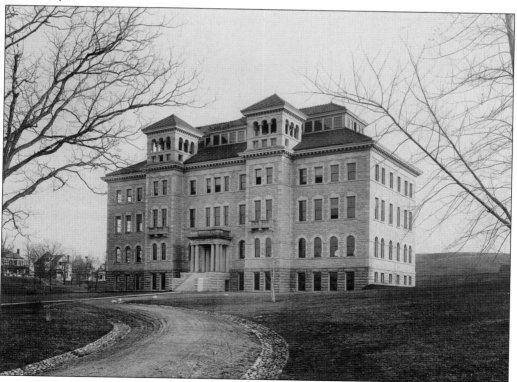

Syracuse Daily Orange

PUBLISHED EVERY MORNING OF THE COLLEGE YEAR BY THE STUDENTS OF SYRACUSE UNIVERSITY.

VOL. I. NO. I. SYRACUSE, N. Y., TUESDAY, SEPTEMBER 15, 1903. PRICE TWO CENTS.

SYRACUSE CREWS SURPRISE EXPERTS

Great Freshman Crew---Stone Elected Captain of 'Varsity.

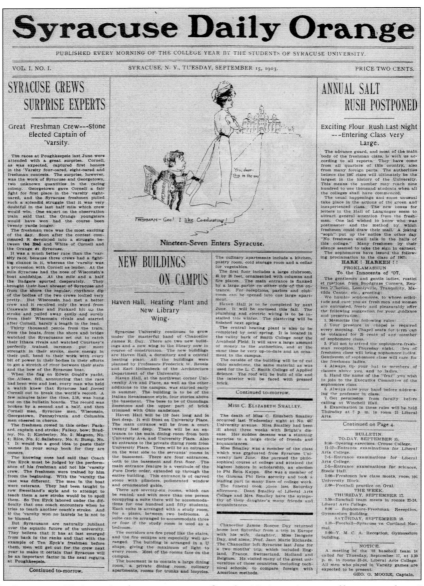

Nineteen-Seven Enters Syracuse.

NEW BUILDINGS ON CAMPUS

Haven Hall, Heating Plant and New Library Wing.

ANNUAL SALT RUSH POSTPONED

Exciting Flour Rush Last Night ---Entering Class Very Large.

In 1903, Syracuse University became one of only 19 American colleges and universities that had a daily student newspaper. On September 15, the first issue of the *Syracuse Daily Orange* was printed. The editors promised the paper would work "to furnish all the college news while it is news, to serve as a bulletin both for Professors, and for student activities, to give the alumni news and news of other colleges, and in all things to unify the interest of all the Syracuse colleges into one great and ever growing University." The *Daily Orange* has known many homes: first, a barn on Raynor Avenue; then, the Orange Publishing Company on Irving Avenue in 1907, Yates Castle in 1934, and a prefabricated building behind Yates affectionately nicknamed "The Hell Box" from 1948 until 1953. In 1971, the paper's budget was cut, and so the last edition of the old *Daily Orange* was published on October 22. The next edition, on October 26, 1971, was of an independent college newspaper, which it has remained to this day.

Designed by architect James Renwick in the 1850s, Yates Castle was purchased by Syracuse University in 1906 as a home for the new Teacher's College. It later housed the School of Journalism. The magnificent 24-room mansion had battlement towers, frescoed walls and ceilings, ornamental plasterwork, and a skylight with painted glass. It was sold to the State of New York in 1950 along with the College of Medicine and demolished in 1954.

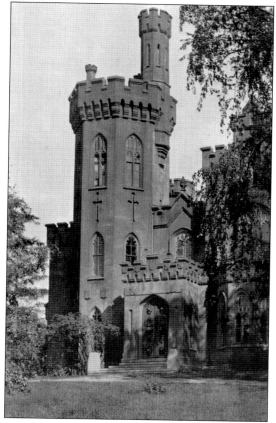

Lyman Hall (1907) was funded by Syracuse University trustee John Lyman's bequest in honor of his deceased daughters, Mary and Jessie. Designed in the Renaissance style by Professors Revels and Hallenbeck, Lyman Hall has undergone numerous renovations. In 1930, a natural history museum was established, uniting the various museum collections previously distributed throughout the building. Laboratories, offices, a seminar room, and a technology center have been added through the decades.

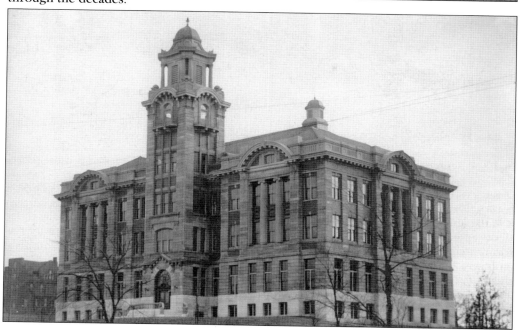

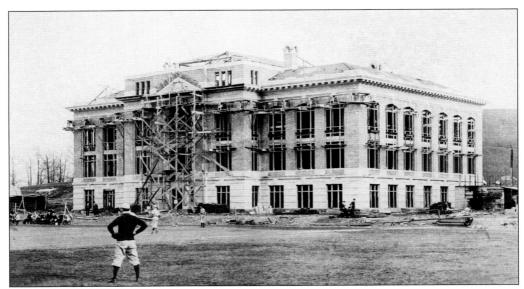

Chemistry faculty and students so badly needed space, they were using Bowne Hall two years before construction was completed in 1909. Named for Syracuse University trustee and donor Samuel Bowne, the building was designed by Prof. Frederick Revels. Changes over the decades have included renovations of laboratories, classrooms, and offices, and construction of the new home of the Syracuse Biomaterials Institute.

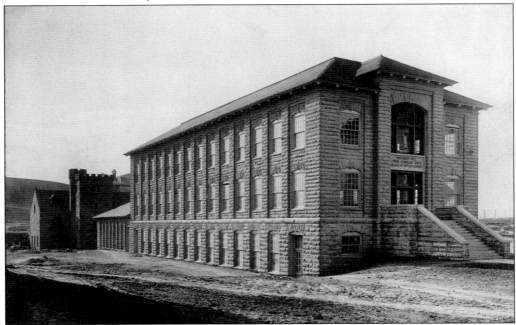

Lyman C. Smith funded Machinery Hall, Syracuse University's second engineering building. Designed by Edwin Gaggin, it was occupied in 1907. After Smith's death in 1910, his widow and son donated a hydraulic laboratory in his memory. Machinery Hall has also been utilized as classroom space, a drama center, and Reserve Officers' Training Corps (ROTC) headquarters. The rear portion was razed in 1953 to make room for Link Hall.

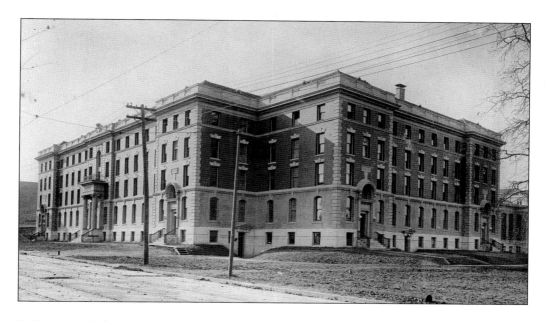

In January 1906, the board of trustees approved Chancellor Day's plan to construct a men's dormitory. Financed by trustee John D. Archbold, the Renaissance-style Sims Hall was designed by Professors Revels and Hallenbeck. The dormitory was named at the opening of the 1907–1908 academic year to honor the third Syracuse University chancellor, Charles Sims. It was divided into five sections, with a dining hall for 250 located on the ground floor. Board and room costs in Sims Hall, including heat and light, varied from $188.50 to $207.50. In the photograph below, John Campbell (class of 1912) relaxes in a typically furnished room. In 1944, Sims became a women's dormitory; it returned to men's use in 1956. A 1,000-seat dining hall was added after World War II. By the 1960s, Sims had been converted into classrooms and offices.

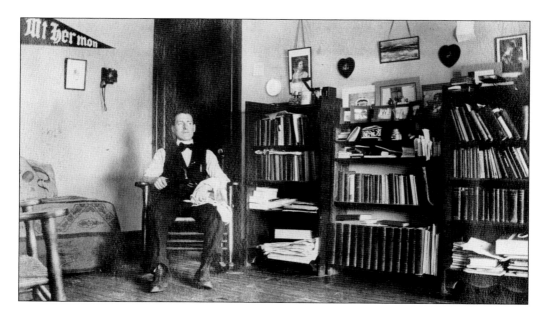

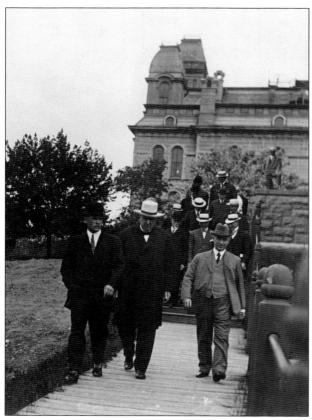

Chancellor Day (center in left photograph) always credited trustee John D. Archbold (right) as the person most responsible for bringing him to Syracuse University. Archbold, vice president of Standard Oil, had promised his friend that "he would make Syracuse University the central object of his benevolence." That benevolence encompassed their shared vision for the institution's expansion. One of the most impressive examples of that vision was Archbold Stadium (below), which was built in a natural hollow on the southwestern corner of the campus. The stadium covered over six acres and seated 20,000. A later expansion increased the capacity to 40,000. At the time of its completion in 1908, Archbold Stadium was called the finest stadium and athletic field in the country and a modern adaptation of the Roman Colosseum.

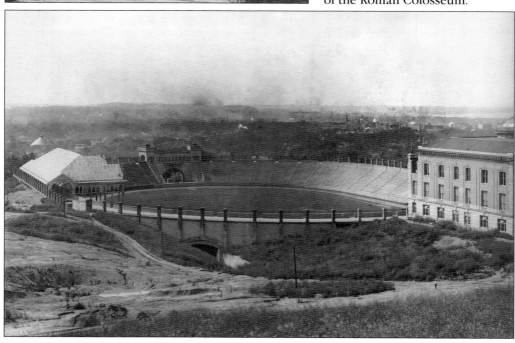

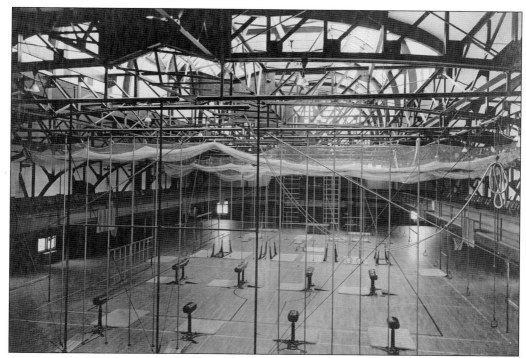

In 1907, the trustees agreed to erect a new gymnasium to alleviate crowding in the old one. Archbold Gymnasium officially opened with the junior prom on December 17, 1908; classes began on March 1, 1909. That June, John D. Archbold paid off the mortgage on the building. The new gymnasium included many amenities. As seen in the above photograph, the floor was devoted to gymnastic training. There were also bowling alleys, a baseball cage, an elevated running track just under the glass dome, and a swimming pool. The building had the nation's first indoor rowing tank for crew practice, pictured below, an accommodation that allowed crew coach James Ten Eyck to ignore Syracuse weather. Commencements held in the spacious gym were also weatherproof, until class sizes outgrew the space.

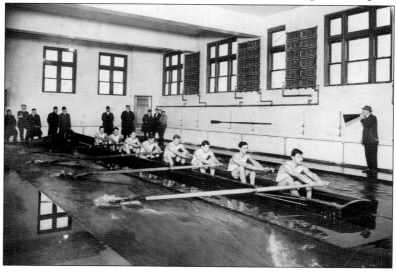

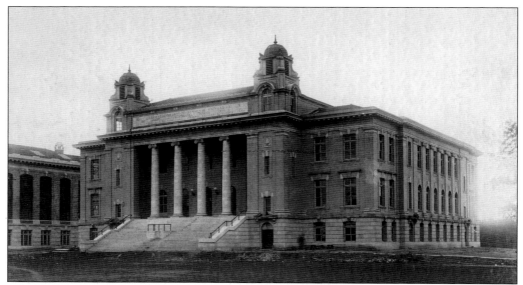

In 1905, Andrew Carnegie donated $150,000 toward a new library, with the stipulation that the university match that amount to endow the building. That money was raised, mostly thanks to John Archbold. Carnegie Library opened in September 1907 with a collection of 71,000 volumes. The library has been renovated several times. It is now one of two original Carnegie libraries on a college campus still being used as a library.

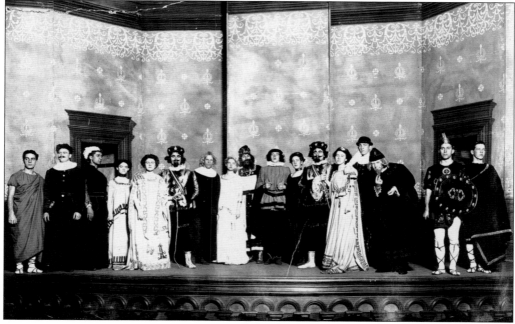

The Boar's Head Dramatic Society was founded by a small group of students in 1904, when they presented *King Lear* under the direction of Prof. Frederick Losey. In February 1906, they adopted Boar's Head as their official name, after a tavern in Shakespeare's *Henry IV*. Boar's Head ended in 1972, having produced over 200 plays. Shown here is the 1911 cast of *The Comedy of Errors*.

Architecture, established in 1882, was one of the early departments within the College of Fine Arts. The department offered the four-year degree of bachelor of architecture. Frederick R. Lear (class of 1905), shown here as a student at a drafting table, was later a professor of architecture at the university. Architecture became a separate school in 1945 and remains one of Syracuse University's 13 schools.

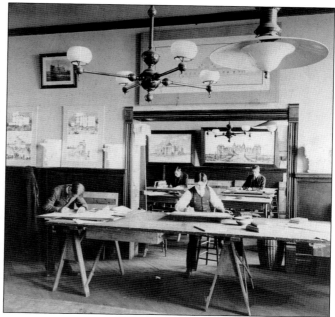

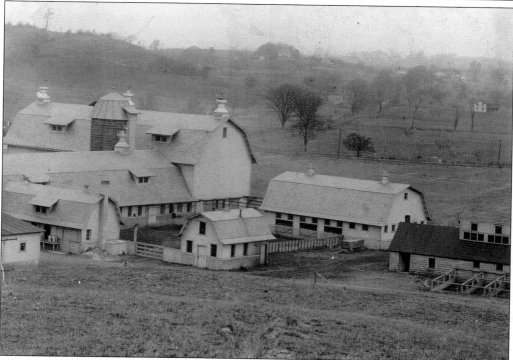

The 1910 *University Bulletin* announces an "Agricultural Institute" and a summary of its four-year program. University benefactor Margaret Slocum Sage supported the endeavor by funding a College of Agriculture in the name of her father, Joseph Slocum. A farm on Colvin Street, including barns and livestock, was purchased. Suffering from a lack of funding and declining enrollment, the college closed its doors in the early 1930s.

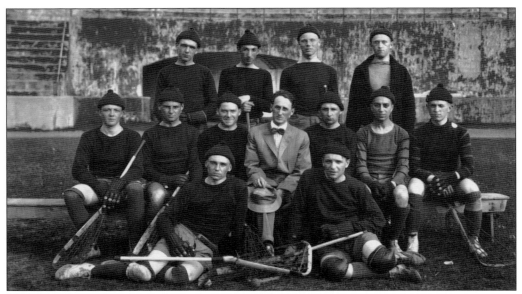

In 1916, College of Forestry students introduced lacrosse to Syracuse University. Two forestry seniors served as manager and captain. Forestry professor Laurie Cox (second row, center), who had played on Harvard's 1908 intercollegiate championship team, was secured as coach. Although initially handicapped by the demands of World War I and a lack of experienced players, this youngest minor sport at the university continued to thrive.

The senior women's honor society, Eta Pi Upsilon, originated the tradition of Women's Day in 1914. Women students annually participated in female-only festivities: a breakfast, May Day pageantry, a maypole dance, athletic events, and the crowning of a May Queen. The evening Lantern Ceremony symbolized the passing of traditions between classes. The May Queen of 1918, Ruth Blount (shown here), as the "Spirit of Light," represented the beauty, personality, and achievement of the class.

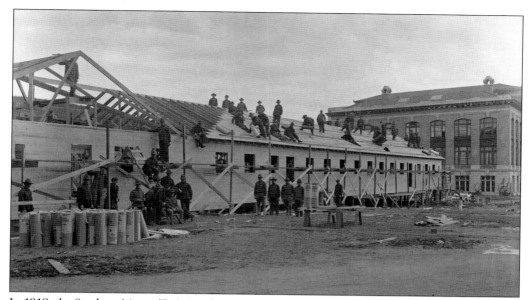

In 1918, the Students' Army Training Corps (SATC), a government military program, dominated campus life. Winchell Hall, Archbold Gymnasium, and Greek houses were converted to barracks, and SATC members built additional facilities on campus. They took basic training and classes in automobile mechanics, telegraphy, surveying, and foreign languages. After the armistice, the corps, which had trained over 1,000 men at Syracuse University, was demobilized.

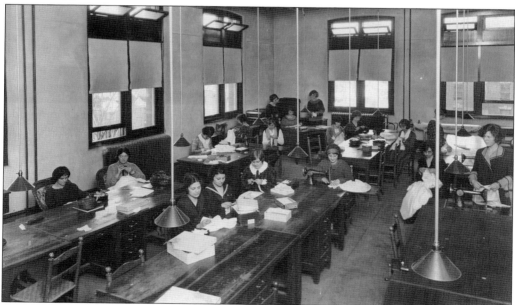

In 1916, Chancellor Day announced that the greatest need in the city of Syracuse was "a college of Industrial Arts and Domestic Science." Home economics, initially offered as a course, soon became a College of Agriculture department. The School of Home Economics opened in 1918 and expanded to a college in 1921. These students are in a sewing class in the basement of Slocum Hall.

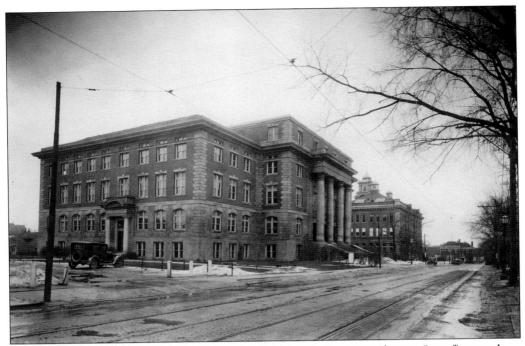

Margaret Slocum Sage financed the building for the Joseph Slocum School of Agriculture in honor of her father, Sen. Joseph Slocum. Construction of Slocum Hall was completed in 1918. The School of Home Economics, the School of Business, and the Fine Arts Architecture Department shared the building with the School of Agriculture. The Renaissance Beaux-Arts building has undergone numerous renovations, including the removal of the main entrance stairs in 1968.

Stimulated in part by the need expressed by returning World War I veterans for training in business, the university began a School of Business Administration in 1919. Much of the impetus for the new school was due to one man, J. Herman Wharton (class of 1911). Wharton guided the school as its first dean, and within two years, the school was elevated to the rank of college.

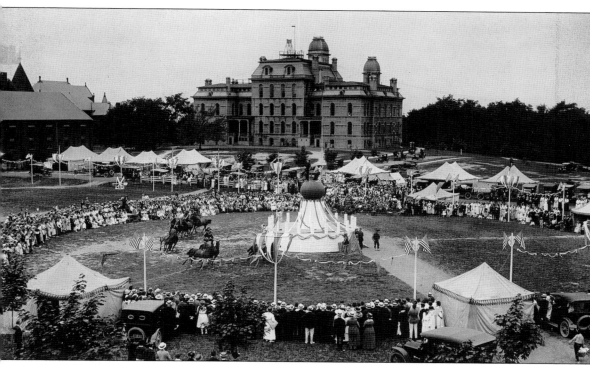

In 1920, Syracuse University celebrated its 50th anniversary. Called the "Golden Jubilee" and taking place on June 10–14, the celebration was like none seen before at Syracuse. An airplane dropped thousands of orange flyers announcing the festivities all over the city and campus. The weekend featured lectures and speeches, a music festival, and an art exhibit. The alumni portion, called "Gradspree," was touted as a "bang-up panorama of color and merriment." There was a parade made up of floats from many of the alumni classes. The annual alumni show was called "Golden Glow," while the alumnae presented one called "Nifty-Fifty." On the Old Oval, now the Quad, there was a large birthday cake with candles. On top was an orange with a hidden ladder from which performers appeared. The Boar's Head Dramatic Society offered five tableaux, the second of which was called "The Founding," featuring students dressed in Native American costume riding bareback around the cake. Sobering as well as celebratory, the weekend also paid homage to those who had given so much during World War I.

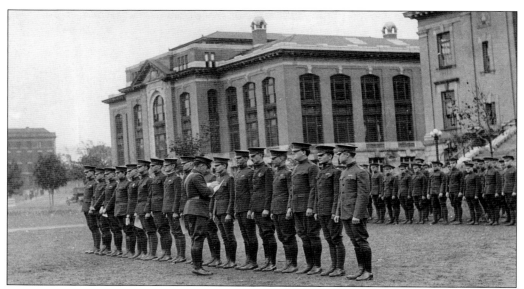

Addressing the need for trained soldiers during World War I, the federal government in 1918 established the ROTC, in which college men could receive training in both military and academic subjects. Syracuse University established a Department of Military Science and Tactics within the College of Liberal Arts, and the first meeting of ROTC on campus was held in March 1919.

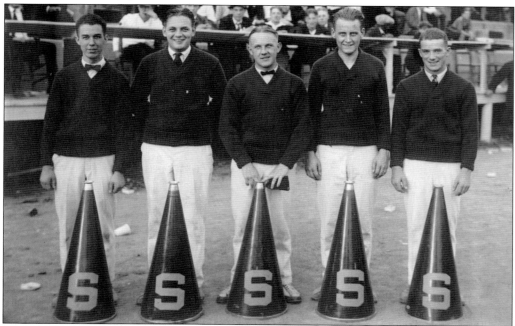

Five Syracuse University cheerleaders stand in a row in the early 1920s. Cheerleaders have always embodied school spirit, but the earliest ones at Syracuse University were male students. The block S letters on their megaphones are a striking and iconic symbol of the university. The S, established as an athletic insignia, was officially first worn at a sports event (a baseball game) in 1893.

The university recognized rifle shooting as a minor sport in the spring of 1919. The Women's Rifle Club of Syracuse University, organized in 1920, had the distinction of being the first college women's rifle team. Within a short time, the club became one of the most popular for women in the university. The team also excelled. In 1921, the ROTC challenged the women's team and was defeated.

The Moving Up tradition began at Syracuse University in 1876 and became a part of commencement activities in 1893. During the Moving Up ceremony, the chancellor requested the seniors to rise from their chairs. Juniors moved into the vacated seats, sophomores took the juniors' places, and freshmen moved to their chairs. The event encompassed a Moving Up Day Parade, including spectacles such as this "float" of freshman engineering students in 1921.

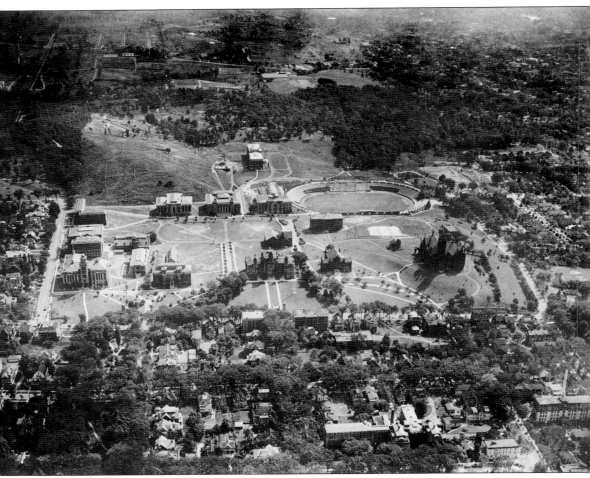

By the end of Chancellor Day's tenure in 1922, university enrollment had increased over 800 percent. This 1920s aerial captures the essence of what is known today as Syracuse University. Beginning with the Old Row, the buildings are, from left to right, Lyman (lower left corner of campus, with tower), Machinery, Smith, Hall of Languages, Tolley, Holden, and Crouse College; (second row) Slocum, the Powerhouse, Women's Gymnasium (behind the Hall of Languages), Steele, and the Photography Building; (third row) Sims (the L-shaped building), Bowne, Carnegie, Archbold Gymnasium, and Archbold Stadium. Note the stadium grandstand is being removed for additional seating. In the center lies the new quadrangle that replaced the original playing field referred to as the Old Oval. Victorian homes surround campus, most of which would later fall to continued campus development. Mount Olympus lies empty; it would be another 30 years before dormitories appeared there. The Great Depression and war would necessitate few changes over the next 20 years. In fact, there would be little change until the returning World War II veterans caused the university to once again evolve.

Three

A FORWARD-LOOKING UNIVERSITY

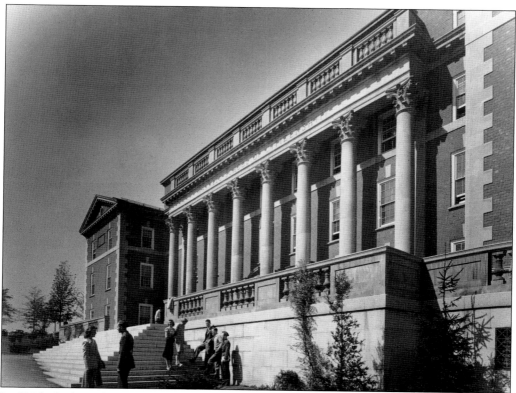

In 1924, the board of trustees, embracing a forward-looking vision for Syracuse University, accepted Chancellor Flint's proposal to establish a "School of Citizenship and the other social sciences." In 1928, George Maxwell, trustee and 1888 alumnus, agreed to erect a building for the new college. Due to his death in 1932 as well as the Great Depression, construction of Maxwell Hall was not finished until 1937.

Charles Wesley Flint (1878–1964) was chancellor between 1922 and 1936. Lauded for pulling Syracuse University out of financial trouble and eliminating its deficit, he expanded the School of Education and established the School of Journalism and the Maxwell School of Citizenship and Public Affairs. An Army Reserve colonel, Flint defended Prohibition and banned smoking on campus. He left the university to become a bishop of the Methodist Episcopal Church.

Syracuse University students enjoy a bonfire at the Bill Orange Halloween Barn Party in 1923. Chancellor Flint, his wife, faculty members, and 1,500 students traipsed up to what is now South Campus to celebrate Halloween. They enjoyed dramatic and comical skits by students and faculty and toasted marshmallows. Two big bonfires were lit "to afford light, heat and protection from any stray spooks that might be roaming through the night."

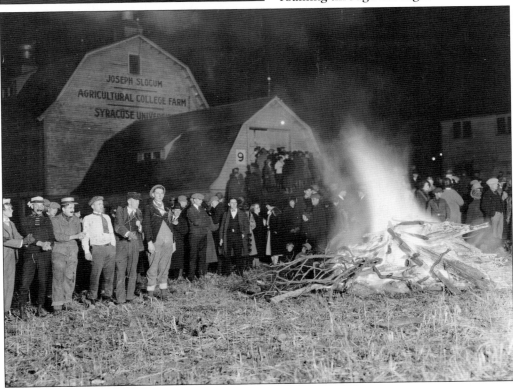

During the 1920s, Syracuse University's mascot was Vita the Goat, who made appearances at home football games in Archbold Stadium. The university's yearbook, *Onondagan*, notes in 1925 that the goat was "held in leash by freshman guardians" during the games. Usually, she was dressed for the occasion with a sign that had slogans such as "Beat Colgate."

In the early 1920s, Laurie Cox, a professor in the College of Forestry, constructed a toboggan run on Mount Olympus. The slide ran down the hill, between Bowne Hall and Carnegie Library, to the Old Oval. Syracuse has always been notoriously snowy in the winter, so the toboggan run was an excellent way for students to make the best of frosty weather.

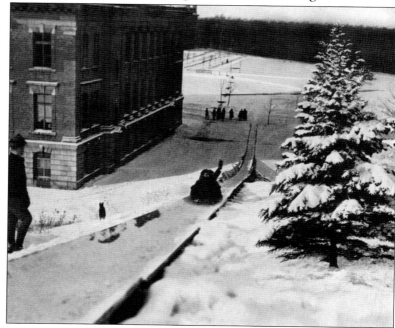

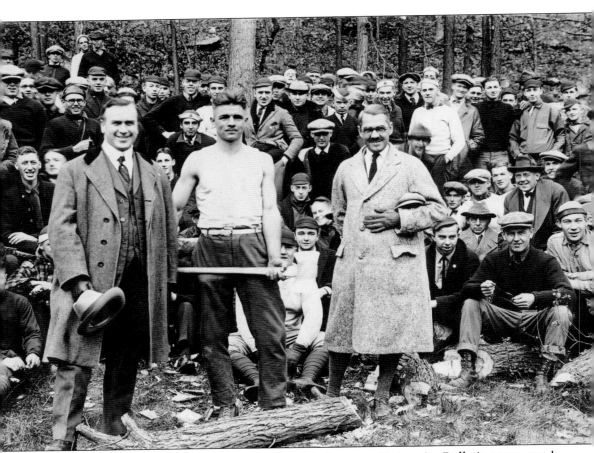

The teaching of forestry dates to 1908, when the *Syracuse University Bulletin* announced an initial course within the Botany Department. By 1910, Chancellor Day was lobbying for the creation of a College of Forestry in Syracuse, which Gov. John Dix formally established on July 28, 1911, as the New York State College of Forestry at Syracuse University. Day told the board of trustees that "the New York State College of Forestry should be the best in the country, for this is the greatest State in the country." Now known as the New York State College of Environmental Science and Forestry, the college remains a separate institution but enjoys a special relationship with Syracuse University. Forestry students take part in university activities, and the two schools share classes and participate in a joint commencement. Shown here in the 1920s is the annual barbecue sponsored by the College of Forestry. Pictured in the foreground are, from left to right, Chancellor Flint, wood-chopping contest winner Austin C. Bilby, and forestry dean Franklin F. Moon.

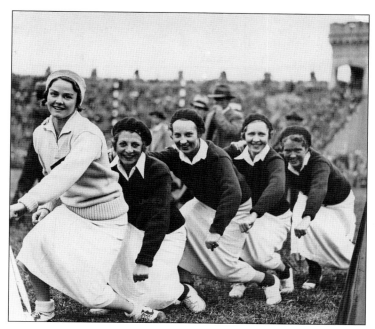

The head cheerleader and her cohorts crouch for a cheer in Archbold Stadium in the 1930s. After decades of male-only participation, women eventually were allowed to take part—but only in the women's seating section. In Syracuse University's early years, men and women sat in separate sections. That practice stopped after World War II, and the cheerleading squads were integrated as well. Over time, cheerleading became dominated by female students.

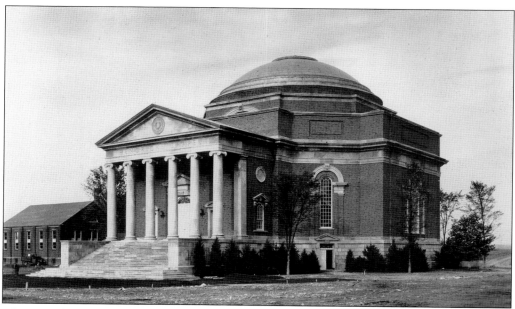

A bequest from Syracuse University and College of Forestry trustee Sen. Francis Hendricks provided for a chapel of all faiths to be built in honor of his late wife, Eliza Jane. Opened in 1930, Hendricks Chapel seated 1,450 and was the third-largest university chapel in the country. The Georgian Colonial chapel was designed by architects James Russell Pope and Dwight James Baum. (Photograph by Jasper T. Crawford.)

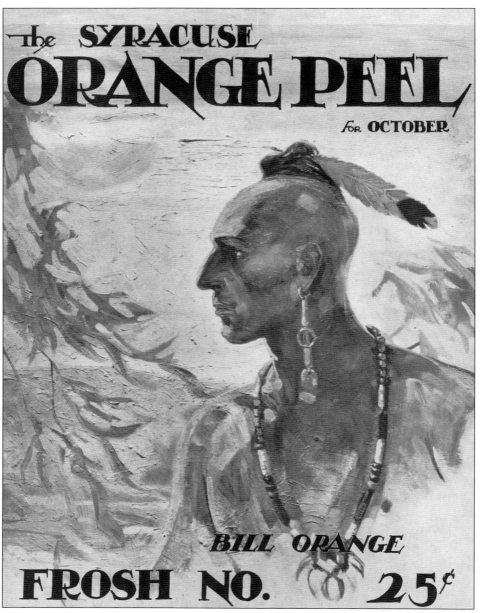

THE SYRACUSE ORANGE PEEL FOR OCTOBER

BILL ORANGE

FROSH NO. 25¢

The Saltine Warrior was born in a hoax in a 1931 university student publication, the *Syracuse Orange Peel*. Supposedly, a textile fragment bearing a portrait of an Onondaga chief, dubbed Chief Bill Orange, was found during an excavation for a campus building. In the 1950s, a Saltine Warrior costume was first worn at Syracuse football games by a Lambda Chi Alpha fraternity brother. That began a nearly 40-year tradition of the brothers serving as Syracuse University's mascot. In 1978, members of a Native American student organization headed a protest against using the Saltine Warrior as a mascot. Onondaga chief Oren Lyons (class of 1958) explained later that it was "all in the presentation. . . . The thing that offended me when I was there was that guy running around like a nut. That's derogatory." The administration agreed and sidelined the mascot forever.

50

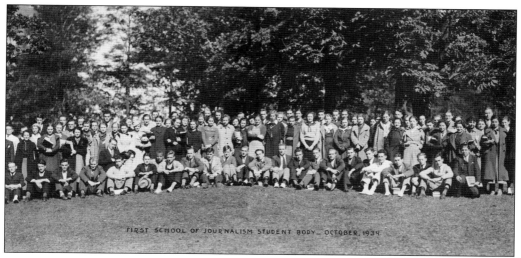

Journalism began as a department within the School of Business Administration in 1919, but slowly gained students and recognition until it was approved as a school in 1934. The first class is shown here on the lawn of Yates Castle, which would be the home of the "Kastle Kids" for the next 20 years. In 1971, the School of Journalism was renamed the S.I. Newhouse School of Public Communications.

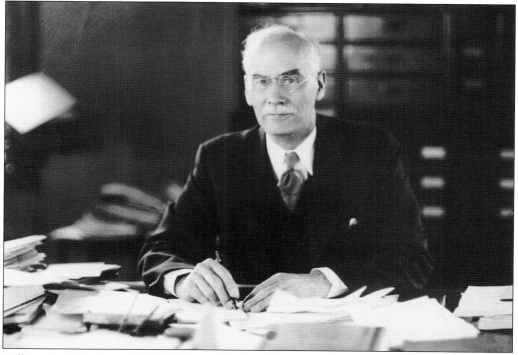

William Pratt Graham (1871–1962) was the first alumnus to become chancellor. He previously was a professor and dean of the College of Applied Science. Graham served as vice chancellor and as acting chancellor until he was appointed chancellor in 1937. He was instrumental in getting graduate status for the Maxwell and education schools. Known for his focus on students, Graham had spent 44 years on the Hill when he retired in 1942.

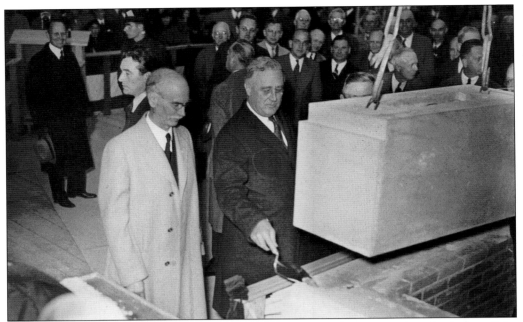

Acting chancellor William Graham accompanied Pres. Franklin Roosevelt at the laying of the cornerstone of Syracuse University's new College of Medicine building in 1936. Roosevelt declared, "I congratulate you with great assurance on the added usefulness to humanity which this building provides and which you will give the future generations of America." The building was sold to New York State with the College of Medicine in 1950.

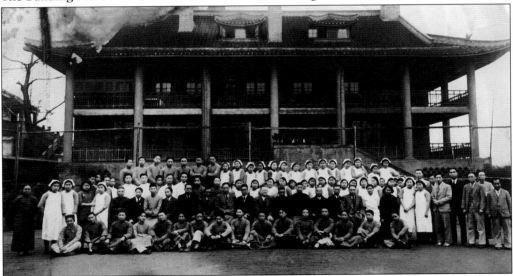

As a Methodist-rooted university, Syracuse developed an early interest in foreign missions. It is not surprising that the university founded Syracuse-in-China in Chungking in 1921 as a threefold mission of medical, evangelical, and educational work. However, the Sino-Japanese conflict in 1937 and World War II nearly ended the mission. The university returned after the war, was ousted by the Communists, but formed Syracuse-in-Asia in Taiwan, which lasted until 1980.

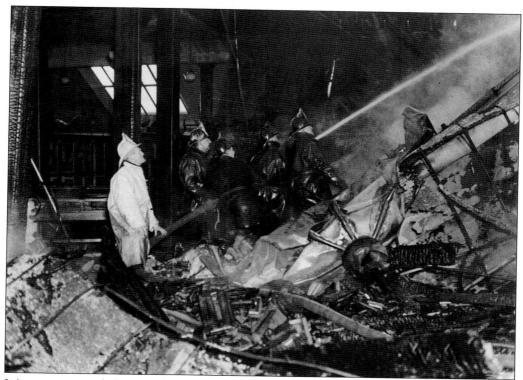

It is not commonly known that Lyman Hall once housed the Syracuse University Natural History Museum, or that the museum was nearly destroyed by fire in January 1937. That fire damaged the top floor and roof as well as valuable museum collections and research materials. The cause was an unattended gas burner that ignited laboratory equipment, photographic film, and a cache of gunpowder, resulting in an explosion and fire.

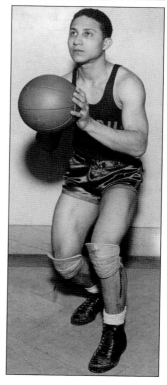

Syracuse University has valued diversity from its inception, offering opportunities to students of all races, nationalities, and genders. African American Wilmeth Sidat-Singh (class of 1939) was an outstanding scholar-athlete who overcame prejudice in his university career while leading the basketball and football teams to winning seasons. He later played professional basketball while working to complete his medical education. As a Tuskegee Airman, he died during a training flight over Lake Huron.

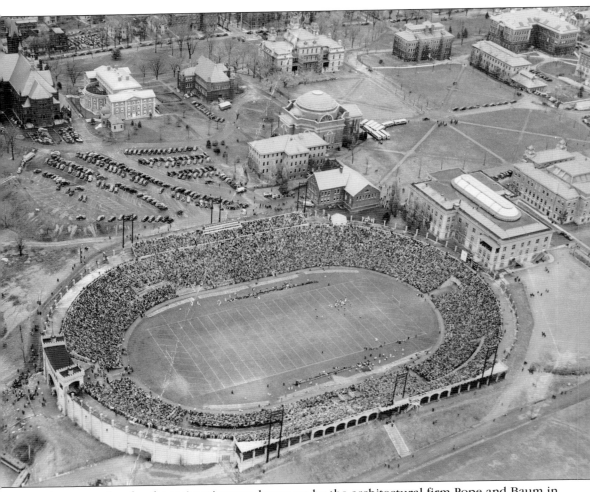

A master plan for the university was drawn up by the architectural firm Pope and Baum in 1928. Proponents of Beaux-Arts principles and Georgian Revival styling, they had a vision for the campus that rejected the eclectic building style that was popular at that time. However, their great conceptual plans did not materialize due to the Great Depression a year later. This late-1930s aerial photograph shows the remnants of the firm's Georgian Revival plan. Hendricks Chapel, which was built in 1930, and Maxwell Hall, which opened in 1937, are the only two buildings visible on the main campus that were not in existence at the close of the Day administration in 1922. The original gymnasium, used by women after Archbold Gymnasium was constructed, was moved behind Steele Hall to accommodate Hendricks. Pope and Baum envisioned a quadrangle to the east of Hendricks, which replaced the Old Oval athletic field. A second quadrangle and a 6,000-seat auditorium west of Hendricks Chapel, where dozens of automobiles are parked, never materialized.

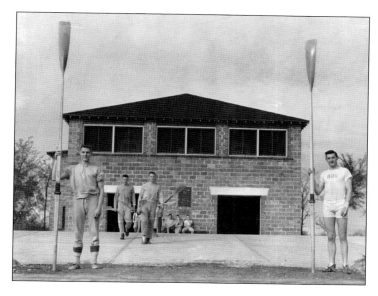

The James A. Ten Eyck Boathouse was named in honor of "The Old Man" of Syracuse University rowing, who coached crew teams from 1903 to 1938. Dedicated in 1937, the new building on the Onondaga Lake inlet replaced a 1911 ramshackle structure. A 1987 renovation enlarged and modernized the structure, including an observation deck and indoor lounge that overlook the course finish line.

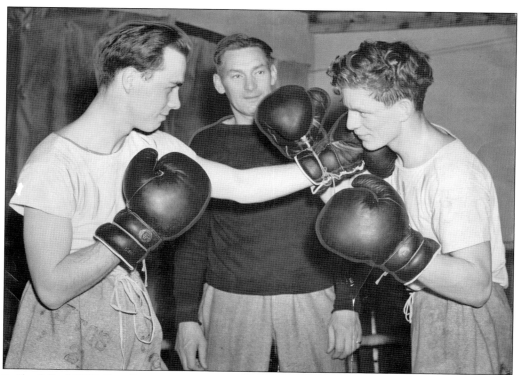

In the fall of 1925, Roy Simmons—Syracuse University alumnus, student body president, and captain of the 1924 football team—was appointed the boxing coach. Under his direction, university boxers earned national distinction and did well in the annual intercollegiates. The teams won the Eastern Intercollegiates in 1932, 1933, 1934, 1937, and 1941 and the National Intercollegiate Championship in 1936.

The George Arents Pioneer Medal is the highest alumni honor bestowed by the university. It is named for George Arents, former chairman of the board of trustees, who endowed a fund in 1939 to provide for annual awards. The Alumni Association Board of Directors selects recipients based on outstanding contributions to their chosen fields. Originally a medallion, the award is now a crystal piece designed by Peter Wayne Yenawine (class of 1969).

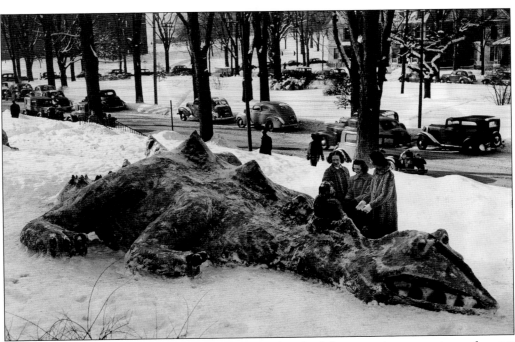

Originating in 1933, Winter Carnival was a weekend of dances, winter sports, and, most important, a snow sculpture contest. Introduced in 1938 as a Greek event, it was expanded to include non-Greek organizations and dormitories by the early 1940s. The sculptures had to embody the annually chosen theme and were judged by a panel of professors and administrators. Seen here is the 1940 winner, Phi Delta Theta's *Alley Oop and Dinosaur* sculpture.

Four

A Victory University

William Pearson Tolley
(1900–1996) was the
seventh chancellor and
the first to also hold
the title of president. A
1922 alumnus, he was
president of Allegheny
College and the youngest
chief executive of
an American college
when he returned
to be chancellor in
1942. Tolley called for
Syracuse University to
be a "Victory University"
during the war. His
27-year tenure saw
dramatic increases
in the university's
facilities, endowments,
and enrollment.

SYRACUSE UNIVERSITY IS READY FOR ACTION!

One critical juncture for Syracuse University came with World War II, when the university made the decision to open its doors to the military. A War Service College was created, which offered a preinduction course for military service and war industry training for women and those not eligible for the draft, as well as continuing civilian education. Training was provided to Air Corps cadets, the Army Specialized Training Program, Women's Auxiliary Corps officers, the Navy V-12 Program, and the Cadet Nursing Corps. By 1945, there were over 8,000 servicemen and servicewomen on campus. This open-door policy helped to pave the way for the thousands of veterans who would join Syracuse University to study under the GI Bill.

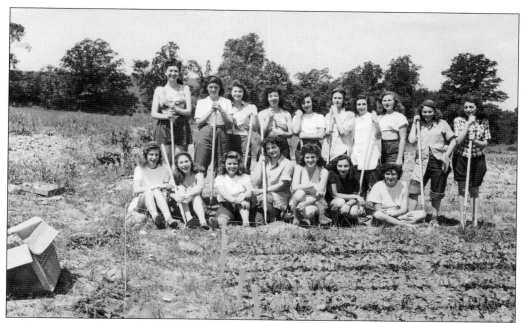

Students take a rest from working on their victory garden in 1945. Even on the home front, Americans participated in the war effort. Because of food and labor shortages, they were encouraged to work together and provide for themselves by planting vegetable gardens anywhere, from backyards to vacant lots. Syracuse University students were among the millions of people who took part in this patriotic and cooperative effort.

The first veterans education plan was announced in 1944, and Syracuse University was quick to accept as many veterans as possible as World War II drew to a close. Classroom space was at a premium, so temporary military buildings were redirected to colleges with high veteran enrollment. Dotting the campus, wherever space was available, were 100 temporary buildings, including these constructed behind Hendricks Chapel in 1946.

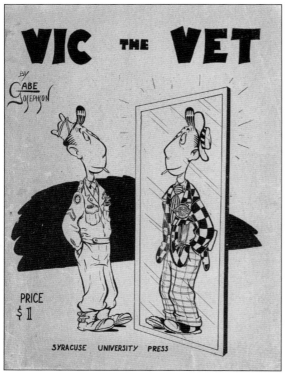

Published in 1947, *Vic the Vet*, by Gabe Josephson, is a cartoon book about a GI studying at Syracuse University under the GI Bill of Rights. Josephson, a veteran of the Battle of the Bulge and recipient of the Purple Heart, was ideally suited to record the trials and tribulations of veterans on campus. After graduation in 1950, Josephson pursued a successful career as a cartoonist, illustrator, and freelance artist.

Among the temporary structures built at Syracuse University after World War II, the most prominent was a dining hall on Comstock Avenue near Colvin Street. Erected in 1947, the Quonseteria served meals for the South Campus residents and provided study and recreational space. Later the Food Service Bake Shop, a storeroom, Microbiology and Biochemistry Center, and wrestling team headquarters, it was demolished in the 1980s.

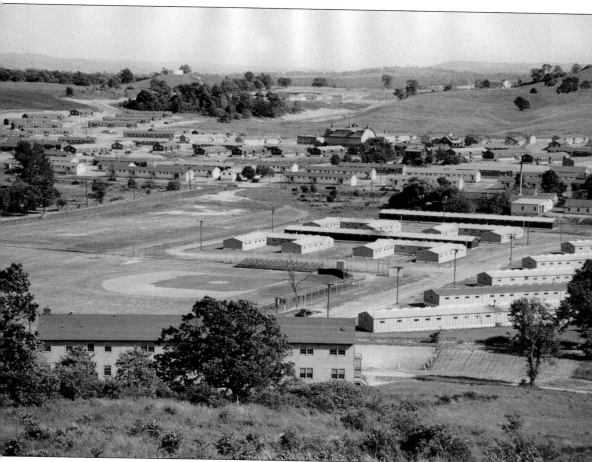

The "GI Bulge" after World War II brought thousands of veterans to campus, and with them came the need for housing. Temporary housing peppered the landscape, from the site of present-day Manley Field House to Drumlins. To address the need for space, the university entered into an agreement with the US War Department to purchase surplus housing units that were made available to colleges with large veteran enrollments. In May 1946, three hundred crated buildings arrived from Lathrop, California, 200 of which were used for housing. Shown here are some of the 22 barracks at Collendale, which held 532 students. Across Colvin Street were 600 military-style housing units, ranging from wooden two-family houses to one-story barracks holding two to twelve families at the former university farm. In an apple orchard at Drumlins were 175 trailers used for married student housing. Until the new housing was ready on campus, students lived all over the Greater Syracuse area, including the New York State Fairgrounds, Baldwinsville Ordnance Works, and the Army Air Base at Mattydale.

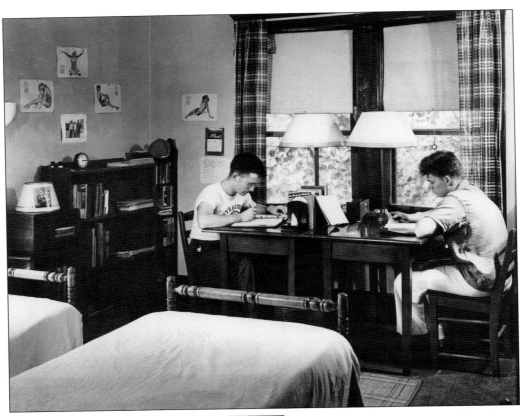

The 1945 *Syracuse University Bulletin* captions this Sims Hall dormitory photograph: "These two students are tackling their homework with ease in pleasant surroundings." Board and lodging ranged from $137 to $200 per term. In 1944, due to the space demands of World War II and an increase in admissions, Sims was converted into a women's residence and remained so until 1956, when it returned to men's housing.

Through the 1940s and until 1952, the Student Union was located in a house at 405 University Place. Attached to the back of the house was one of the myriad temporary buildings scattered across the campus. This particular edifice housed a welcome spot—a diner that was a favorite for many of the veterans attending Syracuse University on the GI Bill.

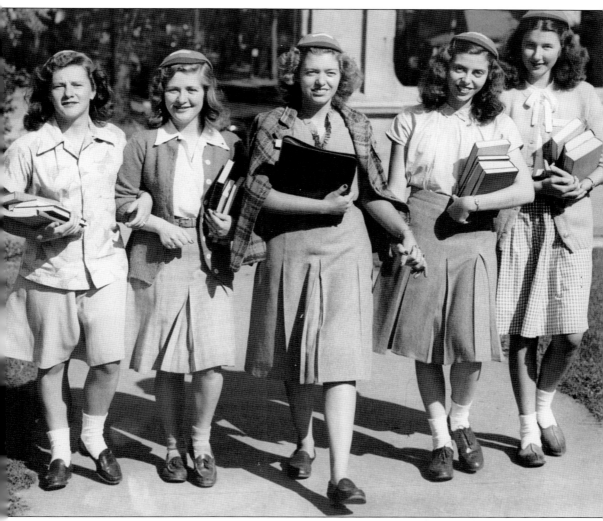

Starting in 1893, all first-year Syracuse University students were required to wear a green or orange soft cap known as a beanie, or lid, during their first semester to distinguish themselves from other students. When told by a sophomore or upperclassman to "Tip it, Frosh," a first-year student was expected to tip his or her beanie in respect. Though wearing beanies could be demeaning at times, it did help first-year students identify each other and build class camaraderie. This group of women from 1946 can be identified easily as first-year students. A group of students known as the Goon Squad enforced the wearing of beanies. Transgressors repeatedly caught without their lids were punished through public humiliation at the Penn State Pep Rally. By the end of the 1960s, though, the tradition of the beanie faded out. An attempt to resurrect it in the late 1970s did not catch on, and the age of the beanie moved into the realm of bygone traditions.

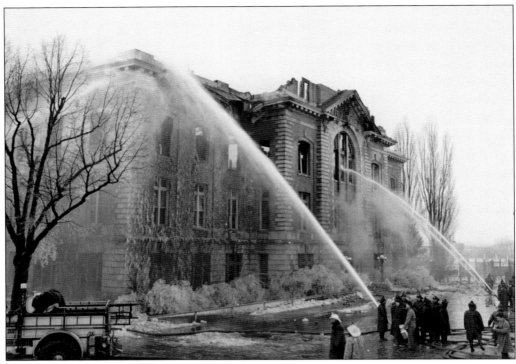

In January 1947, Archbold Gymnasium was almost completely destroyed by fire. Believed to have started in the ground level bowling alleys, the quickly spreading blaze caused the roof to collapse. Extra manpower was needed to save the nearby Carnegie Library. Most of the remaining superstructure had to be demolished. Reconstruction of the gymnasium started in 1948 and was not finished until 1952.

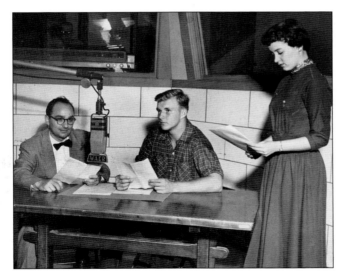

WAER was founded as the Radio Workshop, acquiring an experimental broadcast license in 1947 and becoming permanent in 1951. WAER sought to provide educational services, information for students and the larger community, and experience for radio broadcasting students, such as the early WAER students pictured here. WAER continues to be the university's radio broadcast service, providing music, news, and sports.

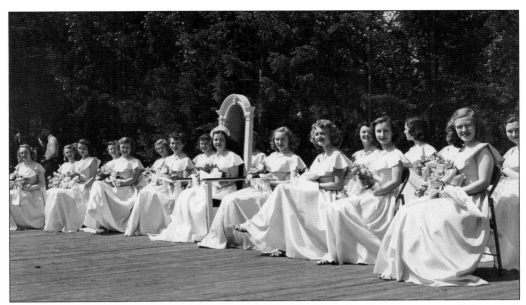

Spring Weekend was an occasion full of traditions that started at the university with Women's Day in the 1910s and lasted through the 1960s. The weekend included a strawberry breakfast, tugs-of-war between classes, and a female chorale competition on Hendricks Chapel's steps. Also popular were the parade of floats and the pageant, when the May Queen and her court, such as these women students in the 1940s, were chosen.

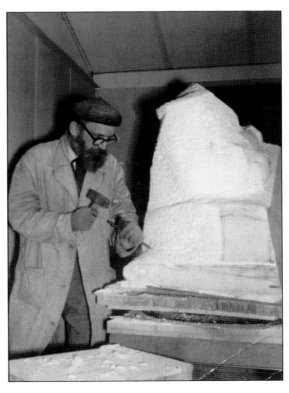

Ivan Meštrovic (1883–1962) was sculptor-in-residence and professor of sculpture at Syracuse University. The Croatian artist was internationally recognized for his work. While in Switzerland, he was invited to Syracuse University by Chancellor Tolley. After Meštrovic arrived in 1947, he became the first living artist to have a one-man show at the Metropolitan Museum of Art. Meštrovic taught sculpture and figure and portrait modeling in a studio near campus until 1955.

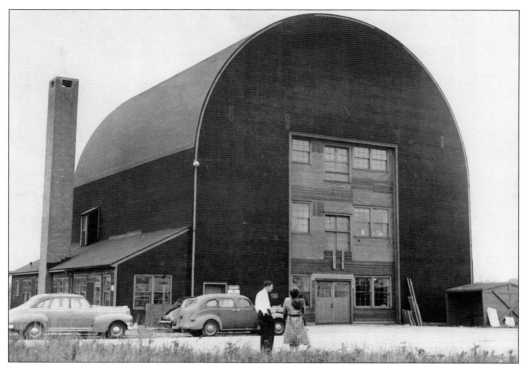

In response to increased interest in technology, Syracuse University opened a 120-acre engineering campus in 1949 at the former naval war plant on Thompson Road. Divided by the War Assets Administration between the university and Carrier Corporation, it was nicknamed "T-Road" by students. It attracted 30 new faculty, enlarging the College of Applied Science from prewar enrollment of 400 to a 1947 enrollment of 1,900, of whom 72 percent were veterans.

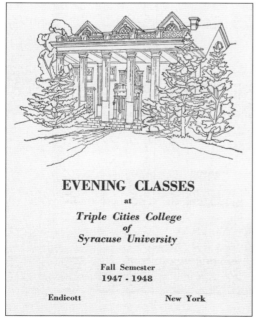

EVENING CLASSES

at

Triple Cities College
of
Syracuse University

Fall Semester
1947 - 1948

Endicott New York

In 1946, Syracuse University launched Triple Cities College in Endicott, New York, and Utica College as extension schools for returning veterans. In 1950, Triple Cities became part of the State University of New York (SUNY) system, and the name was changed to Harpur College. It is now Binghamton University. Utica College remained affiliated with Syracuse University until the mid-1990s. Shown here is an early bulletin cover for Triple Cities College.

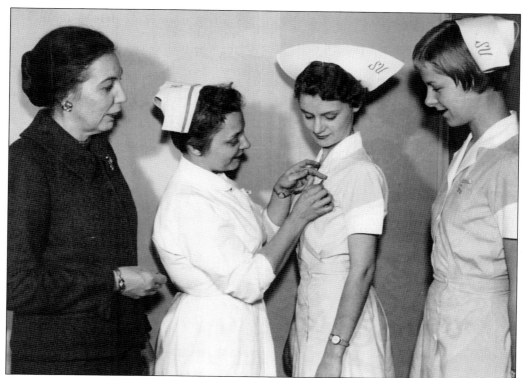

Although the university had offered nursing certificates since taking over the Hospital of the Good Shepherd in 1915, it was not until 1943 that the School of Nursing was formally established, in response to the need for trained nurses during World War II. The official Syracuse University nurse's cap, shown in this 1950 photograph, featured the "SU" initials designed by an art department faculty member.

In 1951, the senior class commissioned a statue of the Saltine Warrior. Art students competed for the honor. The winner, Luise Kaish, had a member of the Onondaga Nation pose for the bronze statue. *The Saltine Warrior* is situated now on the southeast corner of the quadrangle. Shown here at the dedication are, from left to right, Chancellor Tolley, Kaish, senior class president Martin Crandall, Vice Chancellor Finla Crawford, and class poet Donald Weill.

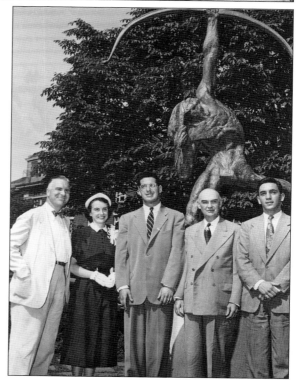

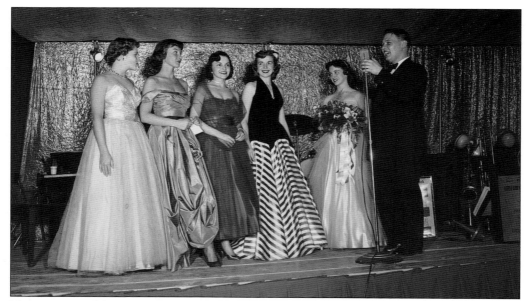

The queen and her court are announced at the 1952 Sno-Ball. Also known as the Junior Prom, the Sno-Ball was a dance held during the Winter Carnival in the 1950s. Dances were a significant part of student life at Syracuse University, affirming campus and social traditions and unifying classes, student organizations, and the student body as a whole.

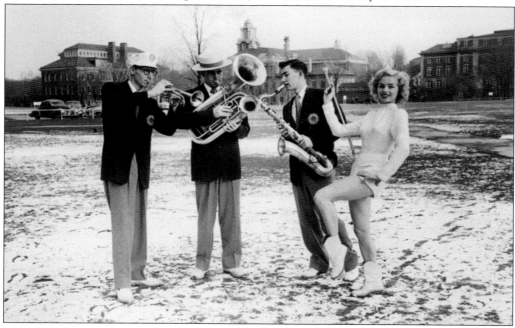

Dottie Grover (class of 1953) poses with marching band members. Dottie was one of the best-known drum majorettes at Syracuse University. Dressed here in her 1953 Orange Bowl outfit, she was national "Sweetheart of Sigma Chi," a *Look* magazine cover girl, and the 1951 National Drum Majorette. The university marching band was once called "100 Men and a Girl." Dottie will always be that girl in many alumni's memories.

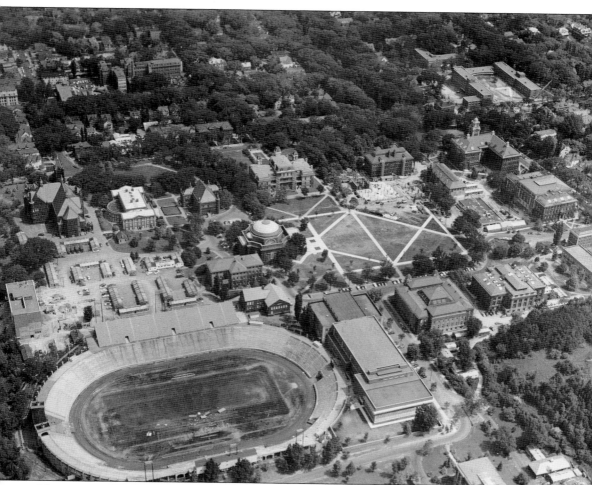

The growth after World War II is evident in this 1954 aerial view of the main campus. Temporary classrooms are in place behind Crouse College. North of Archbold Stadium, White Hall is under construction, signifying the College of Law's long-overdue move to campus. Adjacent to the stadium is the newly renovated and enlarged Archbold Gymnasium, which had been greatly damaged in a fire in 1947. The closing of the Thompson Road facility meant that new space was needed on campus for engineering students. Behind Smith Hall is the foundation for one of the new engineering buildings, now known as Hinds Hall. Farther east, the lower levels of a second engineering building (now Link Hall) are visible, behind Machinery Hall and next to the old College of Agriculture greenhouse, which is still in place. In the upper right corner are the new Watson and Marion dormitories, which opened in the fall of 1954.

Ernest I. White Hall was the ninth building completed in Syracuse University's post–World War II, $15 million construction program. The College of Law, having resided in five city locations since its inception, finally had a home on campus. The building held a library, classrooms, offices, lounges, and practice courtrooms. Additions over the years have included Grant Auditorium, Barclay Law Library, and MacNaughton Hall.

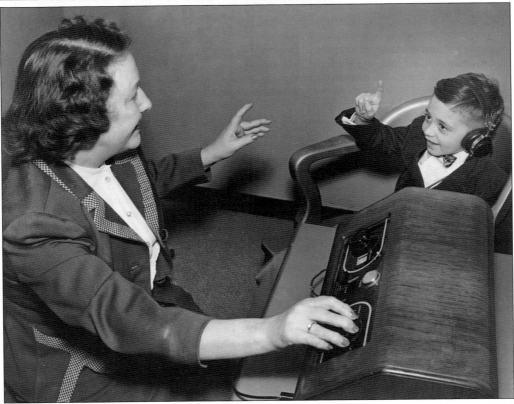

In 1946, the School of Education pioneered a special education program that applied progressive views to teaching people with various disabilities. The emphasis on special education strengthened in later years under education deans Burton Blatt and Douglas Biklen. This 1950s photograph of the testing of a child's hearing illustrates a program that was a precursor to the Gebbie Speech-Language-Hearing Clinics, founded in 1972.

The Women's Building was the culmination of a nearly 50-year effort to establish a building for women's activities and physical education. Until 1909, Syracuse University's gymnasium was almost entirely utilized by male students; women were given limited time to use separate sections. When Archbold Gymnasium was built, the men moved to the new facility and the women were left the "old gym," a building clearly showing its age and limitations. Beginning in 1903, the Women's League, the Women's Athletic Association, alumnae clubs, and myriad other Syracuse University women's groups collaborated on fundraising activities. Untiringly championed by professor of physical education Katherine Sibley, a new women's facility finally resulted after decades of campaigning. The Women's Building was designed by Lorimer Rich and Robbins L. Conn. Occupying the building in 1953 were Women's Physical Education, Dean of Women, Women's Student Government, the Panhellenic Association, and the Women's Athletic Association. The Women's Building served as the hub for intercollegiate women's athletics until 1982, when they merged with the men's program and moved to Manley Field House.

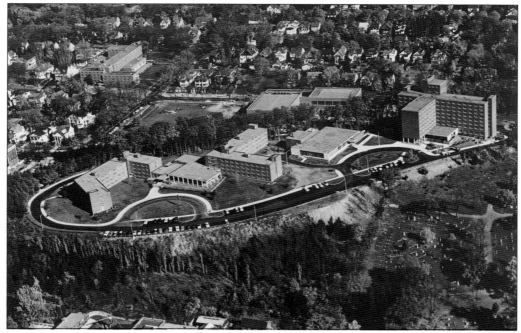

With an increasing need for dormitory space in the 1950s, Chancellor Tolley turned to King & King Architects. They designed Flint Hall (left) in 1956 and Day Hall (right) and Graham Dining Center in 1958. This trio of buildings, named for former chancellors and built on the highest spot on campus, became known collectively as Mount Olympus and provided new housing for almost 1,000 women.

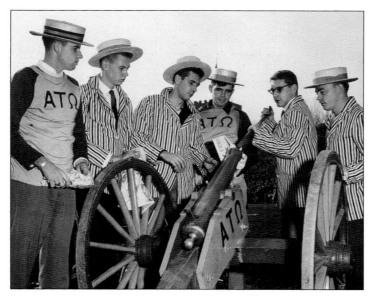

A 38-year football and Greek tradition, the Alpha Tau Omega cannon was a gift from a 1922 alumnus. Four Alpha Tau Omega brothers, called cannoneers, fired the cannon for every Syracuse touchdown at home football games. In 1960, at a game against Penn State, the cannon accidently exploded, flinging five students into the air. No one was badly injured, but university administration thereafter prohibited the cannon.

Worn by Jim Brown (class of 1957), the football jersey number 44 became an icon of Orange football excellence, carried forward by Ernie Davis (class of 1962) and Floyd Little (class of 1967). In 1955, Brown (shown here) led Syracuse to a 5-3 record, earning All-East honors. As a senior, he was a unanimous All-American pick, finished third in the nation in running, and was Syracuse University's first four-letter man (football, track, basketball, and lacrosse) since 1939.

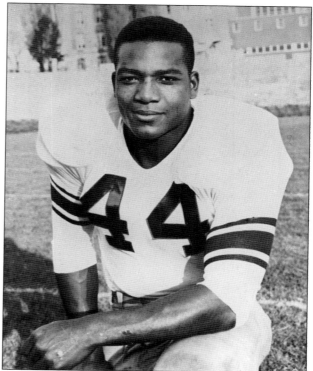

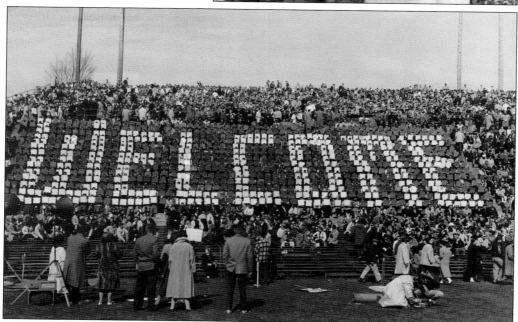

Placard cheering was a Syracuse University freshman tradition. First-year students were expected to enthusiastically cheer at football games, where they sang class songs and participated in placard cheers. When held up all at once, the placards displayed colors, shapes, or words. In this 1957 image, freshmen use placards to spell out the word *welcome*.

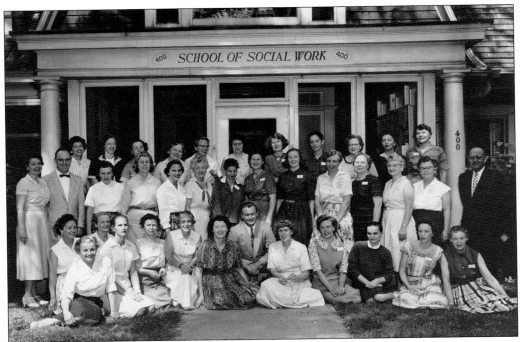

Social work classes began in 1946, taught through University College by University of Buffalo faculty. A formal school was established in 1955 for practicing social workers and those entering the profession. Funded by a major gift from the Rosamond Gifford Charitable Corporation, the school was first housed in Crouse House at 400 Comstock Avenue. Here, attendees of a workshop for child caretaking gather in front of the building in 1959.

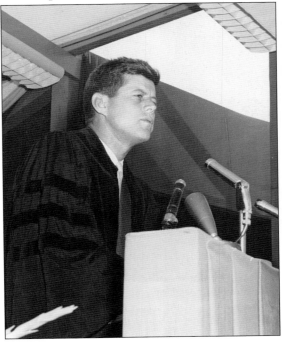

In June 1957, Sen. John F. Kennedy was the commencement speaker at the annual ceremony in Archbold Stadium. He spoke of politics, but also of how graduates should be concerned not over what they leave behind but what they take with them, what they will do with it, and what contribution they can make. Kennedy was called "an apostle of political courage" when he received his honorary degree.

From 1891 to 1961, the annual Colgate Weekend centered on a football game with Syracuse's great rival, Colgate University. The weekend also included bonfires, dances, wild parties, raids on Colgate's campus, and the annual Tau Sigma Delta–sponsored poster contest. Greek and residence houses on campus would create giant placards with a "Beat Colgate" theme, like this one from the 1950s. Prizes were awarded to the houses with the best posters.

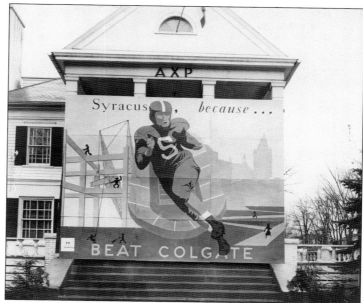

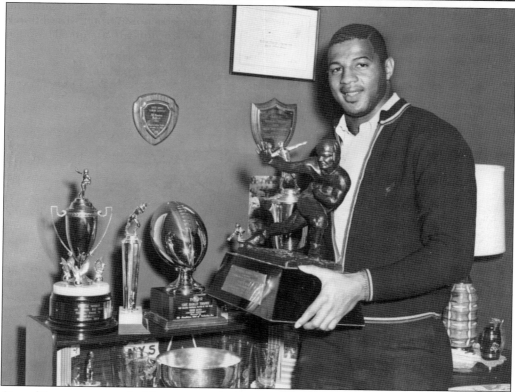

One of the most recognizable names in the history of Syracuse University football, Ernie Davis, along with Jim Brown and Floyd Little, was one of the proud wearers of number 44. As a sophomore, the "Elmira Express" helped lead Syracuse University to the national championship. In 1961, Davis became the first African American to win the Heisman Trophy.

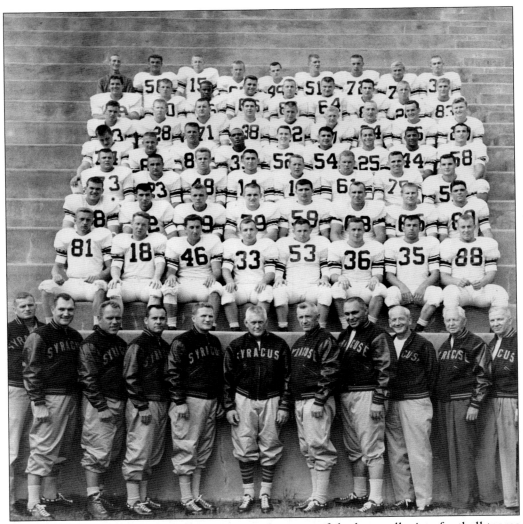

The 1959 Syracuse University Orangemen rank as one of the best collegiate football teams of all time. With a backfield dubbed the "Four Furies" (quarterback Dave Sarette, halfbacks Ger Schwedes and Ernie Davis, and fullback Art Baker) and a defensive line known as the "Sizeable Seven" (Fred Mautino, Maury Youmans, Bob Yates, Bruce Tarbox, Al Bemiller, Roger Davis, and Gerry Skonieczki), the team finished its season undefeated. It won the university's only national football championship, defeating the University of Texas 23-14 in the 1960 Cotton Bowl. The entire first string made at least Honorable Mention All-East. Roger Davis, Ernie Davis, Bob Yates, and Fred Mautino were named All-Americans, and Ben Schwartzwalder was named coach of the year. The team was first in rushing offense, total offense, points scored, rushing defense, and total defense. Heisman Trophy winner Ernie Davis is in the fifth row, second from right. Coach Ben Schwartzwalder stands in the center of the first row.

Five

AN OPEN INSTITUTION

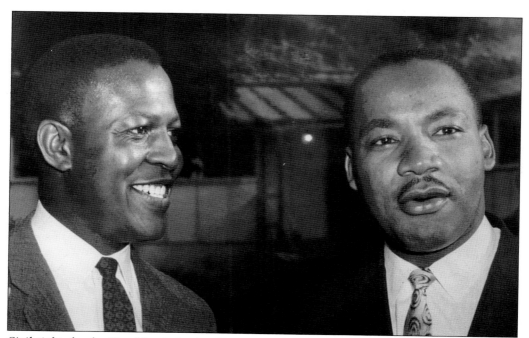

Civil rights leader Rev. Martin Luther King Jr. (right) visited the Syracuse University campus twice in the 1960s to speak at the annual Summer Sessions dinner. In 1961, he delivered a talk on "Facing the Challenge of a New World." On his return in 1965, King, shown here with Syracuse University vice president Charles V. Willie, gave a speech titled "The Role of Education in the Civil Rights Movement."

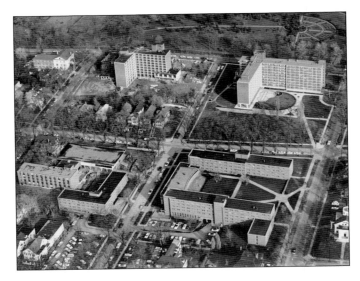

This c. 1963 photograph of Waverly Avenue shows dormitories constructed in response to increasing university enrollment. Marion Hall (bottom left) and Watson Hall (bottom right), which opened in 1954, were designed by Lorimer Rich and King & King Architects. Also designed by King & King, Dellplain Hall (upper right) was built in 1961 and its companion dorm, Booth Hall, in 1963. All four residences were named for Syracuse University trustees.

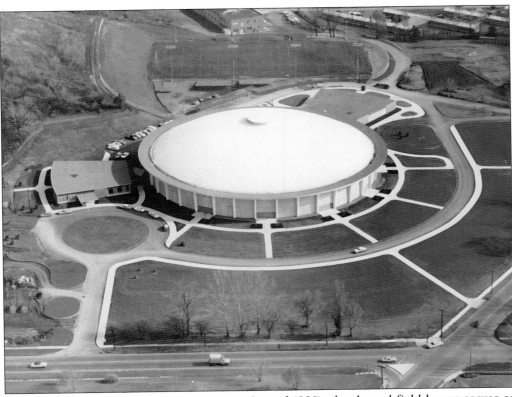

Named for trustee George Leroy Manley (class of 1920), the domed field house serves as headquarters for the university's athletic department. Completed in 1962, the all-purpose facility was the home field for Syracuse University basketball and track and provided sheltered practice for baseball, lacrosse, and football. Manley Field House has been used for other events as well, including commencements, concerts, and registration for classes.

Seen in the below photograph, Newhouse I (right) and Newhouse II were constructed in 1964 and 1974, respectively, for the Newhouse School of Public Communications, named for publishing mogul S.I. Newhouse, the school's founding donor. Pictured above, Pres. Lyndon B. Johnson was the featured guest at the dedication of the I.M. Pei–designed Newhouse I on August 5, 1964. Shown holding his honorary degree, presented by Chancellor William Tolley (right of Johnson), the president used the opportunity to deliver his "Gulf of Tonkin Speech," a reiteration of his televised talk to the nation the previous night. The Gulf of Tonkin Resolution, passed two days later by the House of Representatives and Senate, allowed the president to escalate US participation in the Vietnam War.

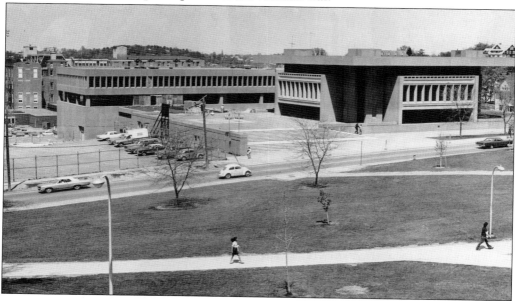

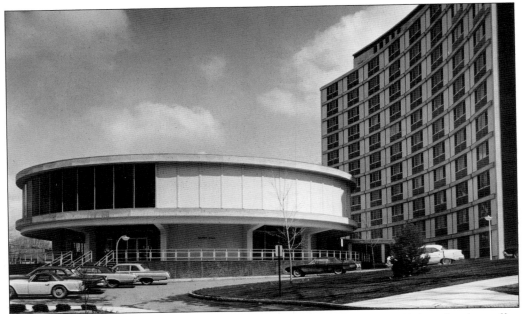

Haven Hall is the second women's dormitory to be named for Syracuse University chancellor Erastus O. Haven. The first, on University Place, was demolished to make way for Newhouse I. Now housing men and women, Haven has a circular wing, and there are eight floors on the Comstock Avenue side and eleven floors on the west side. Students over the years have affectionately called the round wing the "Toilet Bowl."

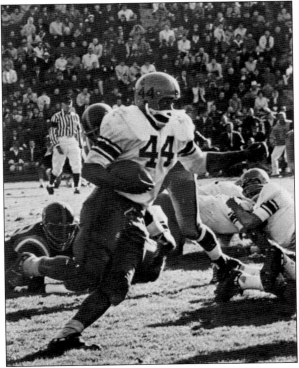

Floyd Little, the "Connecticut Comet," was the third, following Jim Brown and Ernie Davis, to add fame to Syracuse University football's number 44. As a senior, Little surpassed Davis's rushing record and set a career record for most total yardage and most touchdowns. Little held new Syracuse single-season marks for rushing, touchdowns, points, and punt-return yardage and tied the single-season mark for pass receptions.

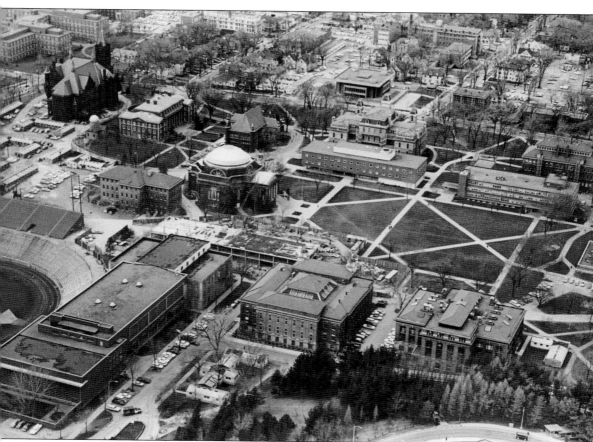

By the summer of 1967, when this aerial photograph was taken, the redbrick rectangular building phase was coming to a close. The construction of the new Physics Building can be seen in front of Archbold Gymnasium, forever separating it from the Quad. The inner row of Quad buildings is in place: Huntington Beard Crouse Classroom Building (between the domed Hendricks Chapel and the Hall of Languages), Hinds Hall to its right, and Link Hall at the right end of the Quad. Newhouse I (the square building above the Hall of Languages) is visible, but it would be several more years before Newhouse II made an appearance. There are still a number of temporary classroom buildings on campus, left over from after World War II. They can be seen behind Crouse College and, at the bottom of the photograph, behind Carnegie Library and to the right of Bowne Hall. A number of attached temporary structures are to the left of Newhouse I as well.

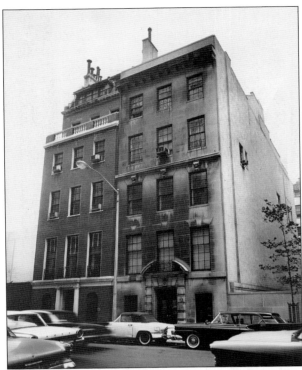

In 1964, Joseph I. Lubin bought and donated a house in New York City to the university. Two years later, Syracuse University purchased the building next door to expand the existing space. With funding from Lubin, the two buildings were joined, and renovations were completed in 1995. Lubin House, Syracuse University's presence in New York City, is a center for many alumni events. (Photograph by Regency Pictorials, Inc.)

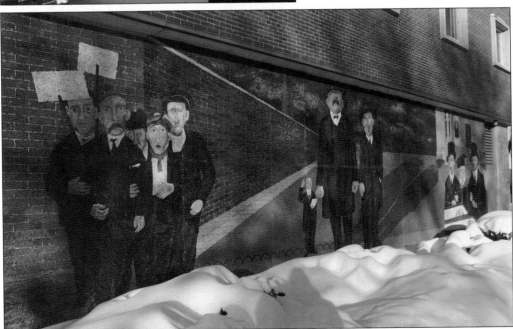

On the east wall of Huntington Beard Crouse Hall is a 60-foot mural, *The Passion of Sacco and Vanzetti*, created by artist Ben Shahn in 1967. The mosaic is made of numerous small pieces of glass and marble. The subject is the trial of Nicola Sacco and Bartolomeo Vanzetti, who were put to death in Massachusetts in 1927 for a crime many believed they did not commit.

John Corbally (1924–2004) was Syracuse University's chancellor from 1969 to 1971. He outlined a plan for reorganizing the central administration and oversaw a new financial structure for the university. During his tenure, Corbally faced student unrest, including the 1970 student strike and the football discrimination crisis. Nevertheless, he said, "A university should remain an open institution so no one has to tear the place apart to be heard."

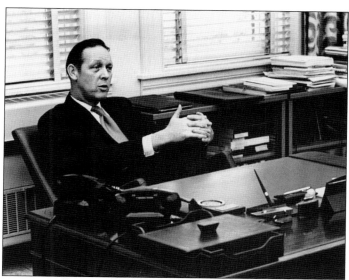

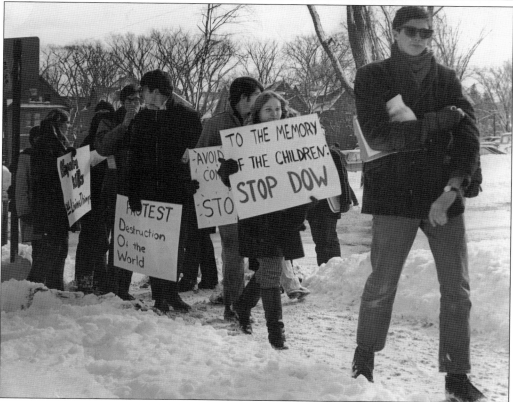

Across the nation in the late 1960s, university students voiced their opposition to the escalation of the Vietnam War. Syracuse University students were no different, protesting against campus recruiting by companies such as Dow Chemical, which supplied napalm for the war at the time. Students barricaded themselves in the Administration Building for several hours.

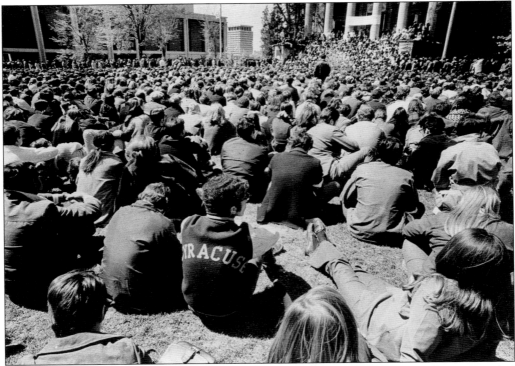

On May 4, 1970, four Kent State University students were killed and nine others wounded by Ohio National Guard troops during a protest against the American invasion of Cambodia. Those killings prompted a nationwide protest by college students that shut down over 400 educational institutions. Oliver Stone's film *Born on the Fourth of July* depicts a major riot on the Syracuse University campus, but that portrayal is fictional. At Syracuse University, the protests ranged from calm to chaotic. Students sat peacefully on the Quad and listened to impassioned strike proponents (above), marched from the main campus in an unbroken line to South Salina Street downtown, and staged a sit-in in the Administration Building. However, students also barricaded all entrances to campus with wire and wood (below), firebombed the bookstore, and broke over 70 windows on campus.

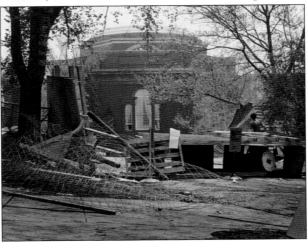

In 1970, Syracuse celebrated its centennial amid a turbulent era of student protest. Still, 100 years of higher education was not to be overlooked. The celebration that spring offered seminars, lectures, concerts, and the naming of six Centennial Professors. There were exhibitions, like this kiosk at Hancock Airport, which featured a four-sided mural portraying contemporary life at Syracuse University. The official centennial symbol can be seen on the left side of the kiosk.

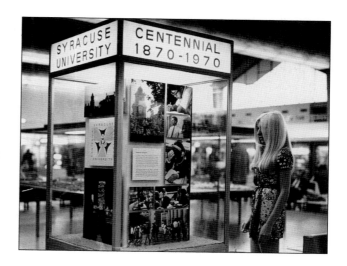

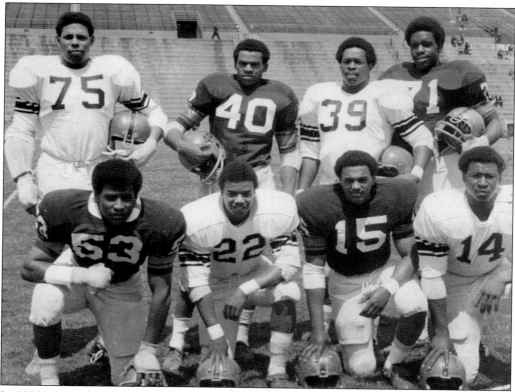

In 1970, nine African American Syracuse football players petitioned for better medical care, academic support, unbiased starting position assignments, and racial integration of the coaching staff. Their demands were ignored, so they boycotted the season, ending their collegiate sports careers and a chance to turn professional. In 2006, recognizing their courage, Syracuse University awarded the Chancellor's Medal to the "Syracuse Eight" (a miscount from the media). (Courtesy of John Lobon.)

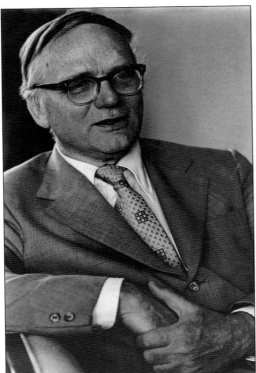

Before becoming chancellor, Melvin A. Eggers (1916–1994) was an economics professor at Syracuse University beginning in 1950. In 1971, shortly after he was named vice chancellor for academic affairs and provost, the trustees chose Eggers to be chancellor. During his tenure, $200 million in campus construction was completed or begun. Student enrollment and the number of faculty reached an all-time high, and the university gained its reputation as a research institution.

Link Hall was one of two engineering buildings planned in the 1950s. Hinds Hall was completed in 1954, but only Link's lower floors were built by then. Construction resumed in 1968, and Link is now the home of the College of Engineering and Computer Science. In 2008, the five-story Link+ Interdisciplinary Wing added engineering research labs and an on-campus presence for the Center of Excellence in Environmental and Engineering Systems.

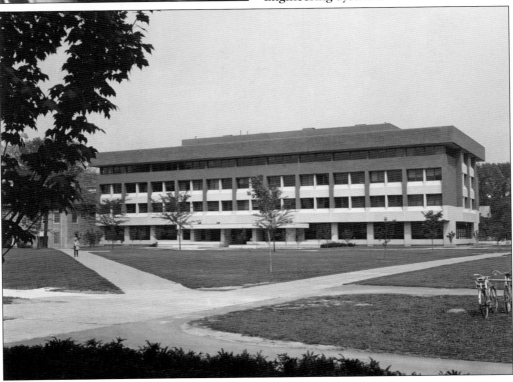

For new Syracuse University students, the first days have always been bewildering. Luckily, the new arrivals have had the Goon Squad, shown here at Shaw Hall in 1971. Since the 1940s, the Goon Squad has helped first-year students move into dorms and adjust to college life. Often wearing straw hats and Jiminy Cricket buttons, they also spread school spirit and led cheers at football games.

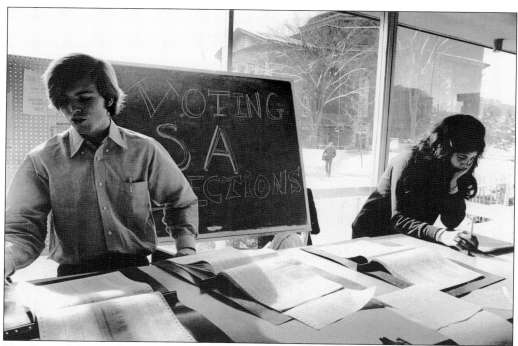

Members of the Student Association, Syracuse University's student governing body, attend elections in 1972. In the early years, male and female students participated in separate governing organizations: for men, first the Senior Council and then the Men's Student Government Association; for women, initially the Women's League and then the Women's Student Government Association. The groups merged in 1957 into the Joint Student Government Association, now known as the Student Association.

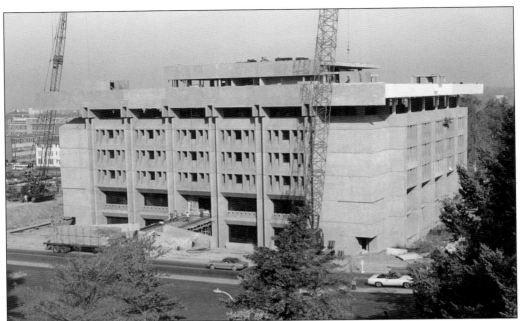

Ernest Stevenson Bird (class of 1916), donated money for Syracuse University's third major library building. E.S. Bird Library opened in September 1972, quintupling the space of Carnegie Library and seating 2,500. Bird centralized most of the library's resources and, for the first time, made available in one building the university's social science, humanities, area studies, reference, periodical, rare book, and archival and manuscript collections.

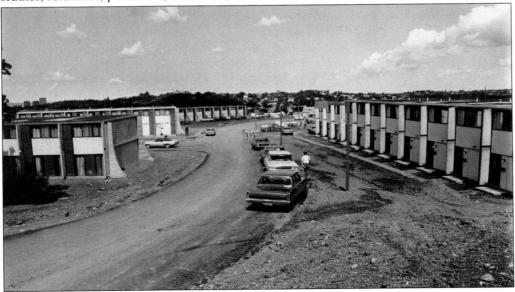

Known as the "Skytop Projects," construction on South Campus in the early 1970s included the Skytop Office Building and the new Slocum Heights Apartments. Most of the existing postwar prefabricated living units were demolished for the new construction. Phase I consisted of townhouses west of Skytop Road; Phase II comprised townhouses and garden apartments east of Skytop Road. The university owns 101 residential buildings on South Campus.

Marshall Street, though not a part of campus, has been Syracuse University's "Main Street" for generations. Affectionately called "M Street," it is the place where students have come to eat, socialize, and shop. These photographs of Marshall Street are from 1973 (above) and 1974 (right). Students have frequented bookstores, novelty and clothing shops, music stores, restaurants, bars, coffee shops, and other establishments located on this street. One of the most well-known and long-standing spots is the Varsity (above), where students have gone for a slice of pizza. Other enduring businesses include King David's and Manny's. Marshall Street has also been a gathering place for students, alumni, and members of the Syracuse community before and after home football and basketball games. (Photographs by Anestis J. Diakopoulos.)

Students watch the band Albatross perform in the Jabberwocky Café in October 1973. The Jabberwocky, or "the Jab," was a student-run nightclub on Waverly Avenue during the 1970s and early 1980s. Its most memorable features were the Alice in Wonderland murals on the walls. All kinds of musical groups performed at the Jabberwocky, including Talking Heads, James Brown, and Funkadelic. (Photograph by Anestis J. Diakopoulos.)

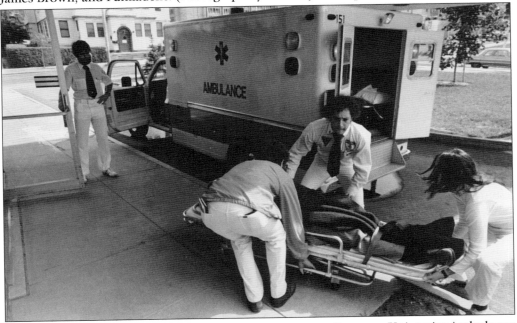

Recognizing a need for emergency services on campus, Syracuse University Ambulance (SUA) is a student organization founded in 1973 by a group of students with just a backpack of medical supplies. Serving as a model for other universities, SUA now functions through Syracuse University's Health Services, operates two ambulances, and annually responds to over 1,500 medical emergencies.

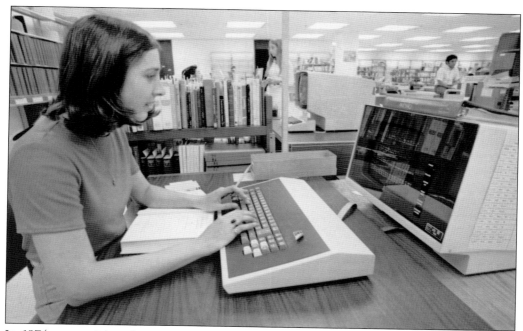

In 1974, recognizing that computer technology was the wave of the future for librarians, School of Library Science dean Robert S. Taylor recommended the name of the school be changed to Information Studies, or IST for short. He correctly envisioned the future, as anyone visiting the libraries on campus can easily attest. In the 2000s, the school would be commonly known as the "iSchool."

Que Pasa was a bilingual magazine printed by the Organization of Latin American Students, a student group that promoted Latin American culture on campus. From its founding, Syracuse University welcomed all races, religions, and national origins. For decades, though, minority students remained relatively few. *Que Pasa* is representative of the increase not only of minority students on campus but also of their visibility and voice in the 1970s.

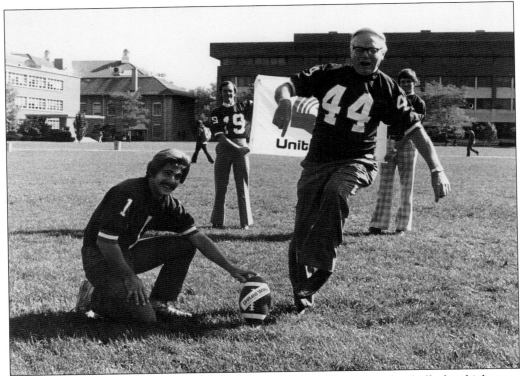

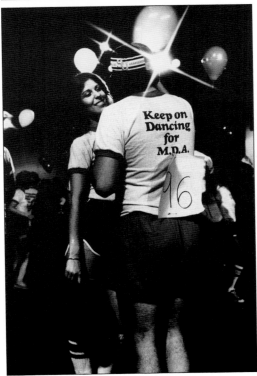

Syracuse University football placekicker David Jacobs helps Chancellor Eggers "kick off" the 1977 United Way fundraising campaign at the university. This was the first year the university reached its financial goal while participating as an organization. The United Way of Central New York funds local charitable groups. For decades, United Way campaign participation has been one of the many ways Syracuse University has given back to the community.

A couple dances at the 1978 dance marathon to benefit the Muscular Dystrophy Association. In 1973, Delta Tau Delta organized the first marathon; the Syracuse University Greek Council later took it over. Local businesses and student organizations sponsored couples to dance for 48 hours. Sponsors raised money through raffles, car washes, contests, and other fundraisers. By 1978, the university's Muscular Dystrophy Dance Marathon had raised $220,000. (Photograph by Paul Hayashi.)

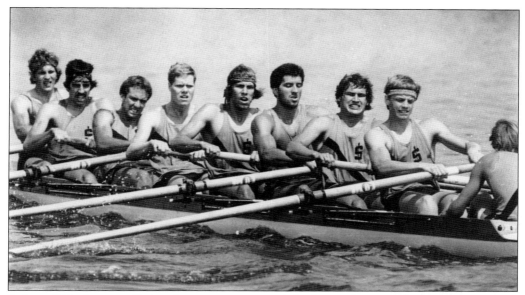

In June 1978, Syracuse University oarsmen accomplished something not done at the university in 58 years. The Varsity Eight brought home the national title for crew, the Intercollegiate Rowing Association (IRA) championship. Held that year on Onondaga Lake in Syracuse, the IRA is the most highly regarded contest in the sport. The Freshman Eight also won, solidifying Syracuse University crew as best in the nation. (Photograph by William Tynan.)

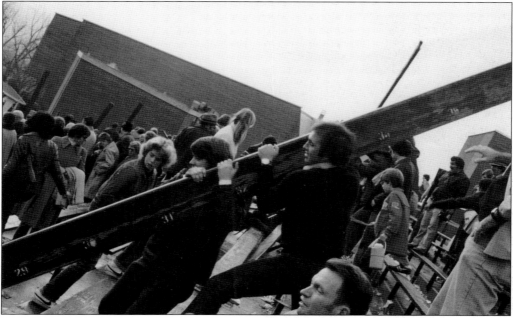

After 71 years, the venerable Archbold Stadium was to be demolished to make way for the Carrier Dome. On November 11, 1978, the Syracuse football team defeated Navy. Before the last whistle, over 26,000 spectators began to claim souvenirs of "Old Archie" before the wrecking ball arrived. As shown here, the crowd took pieces of the goalposts, seats, and even concrete, using hammers and saws. (Photograph by Gay Rudisill.)

In 1973, Syracuse University announced that the iconic Hall of Languages, 100 years old that year, had been placed in the National Register of Historic Places. This made the building eligible for federal preservation grants and allowed the university to reverse the deteriorating condition of the "Dowager Queen" of the campus. In addition to grant money, over 1,000 individuals and foundations made contributions to finance the project. The renovation of the Hall of Languages began in 1978 and entailed a complete gutting and restructuring of the interior of the building (left). When completed (below), the original four-story building was transformed to five floors. It was rededicated on September 6, 1979, in memory of Eric H. Faigle, the former dean of the College of Arts and Sciences, beloved by many Syracuse students during his four decades on campus. (Below photograph by Steven Rosenthal.)

Six

EXCELLENCE ACHIEVED

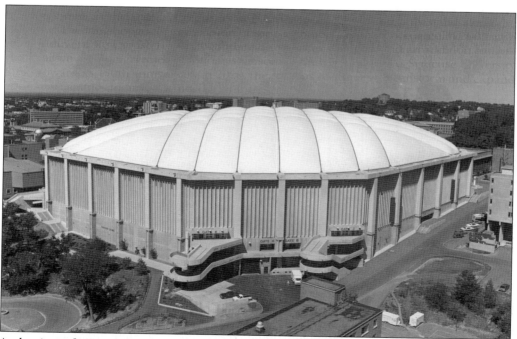

At the time of its completion in 1980, the Carrier Dome was the fifth-largest domed stadium in the United States and the first of its kind in the Northeast. Various events have taken place at the Dome, which can seat 49,262: Syracuse University football, basketball, lacrosse, track-and-field, soccer, and field hockey games; professional and high school athletic events; and university commencements, convocations, concerts, and community events.

Archbold Theatre, part of the Regent Theatre Complex, is located in what was once a 1919 movie theater, purchased by the university in 1958. The 1980 renovation provided an improved, more spacious facility for Syracuse Stage, the university's performance theater in residence. The theater opened with a production of Shakespeare's *The Comedy of Errors* in November 1980.

Founded in 1963 as the first of its kind in the world, the Belfer Audio Laboratory and Archive is the fourth-largest sound archive in the country. Belfer preserves audio materials, including cylinder records, 78-rpm recordings, and audiotapes. Founding director Walter Welch, pictured, was a pioneering phonograph historian and authority on early sound recording processes.

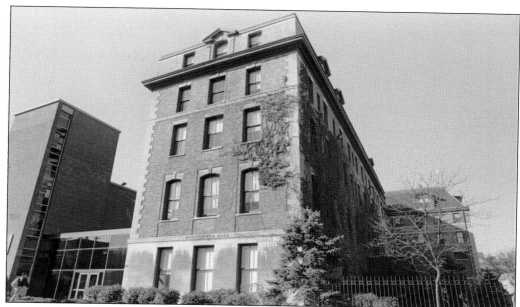

In the summer of 1973, the School of Education was able to consolidate 40 separate locations into Huntington Hall. Formerly the Hospital of the Good Shepherd, the building was renamed for the late Bishop Huntington, the hospital's founder. In the 1980s, Huntington Hall was connected to an adjacent building at 804 University Avenue via a new glass entrance, and the rear of Huntington was totally renovated.

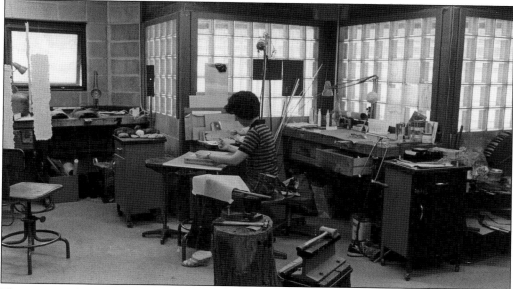

The Comstock Art Facility near South Campus was built in stages as various university art programs were relocated for additional space. The building opened in September 1982, and two additions followed. Works such as fiber arts, sculpture, printmaking, woodworking, and ceramics are created here. The facilities also accommodate jewelry making and metalsmithing in private or semiprivate studios. Student artwork is displayed throughout the year at the ComArt Gallery.

In 1983, the university held a reunion specifically for African American alumni, the first of its kind in the nation. Called Coming Back Together (CBT) and organized by the Office of Program Development, the weekend offered campus tours, lectures, a musical revue, a dinner dance, and, shown here, a reception at the Chancellor's Residence. CBT later expanded to include Latino alumni. Since 1983, there have been 10 reunions for minority alumni.

The Schine Student Center (shown here) was built in 1985, thanks to a financial contribution from trustee Renee Schine Crown. The building's design, involving four radiating wings, was described as a "reflection of the diverse intellectual, cultural, and social interest of the Syracuse University community." In 1990, Ann and Alfred Goldstein, who were responsible for the Schine's Goldstein Auditorium, funded a second student center, the Goldstein Student Center, to serve South Campus students.

The drummer of the Sour Sitrus Society performs during the Syracuse University–Seton Hall University basketball game in February 1985. Student-organized and directed, the Sour Sitrus Society is the university's basketball pep band. Open to all student musicians, the ensemble has played at all men's and women's home games in the Carrier Dome and travels with the team for playoff and National Collegiate Athletic Association (NCAA) tournament games.

In 1983, Syracuse University's lacrosse team reached the NCAA tournament finals against Johns Hopkins University. The team came from behind and beat Johns Hopkins for the first time since 1923. The 14-1 Orange were national lacrosse champions. Since then, Syracuse University lacrosse has remained a powerhouse, winning national championships into the 2000s. (Photograph by Karen Rusinski Williamson.)

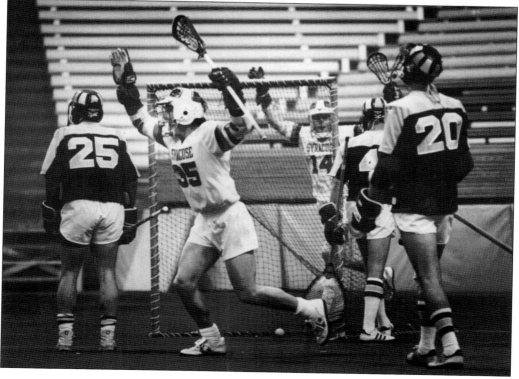

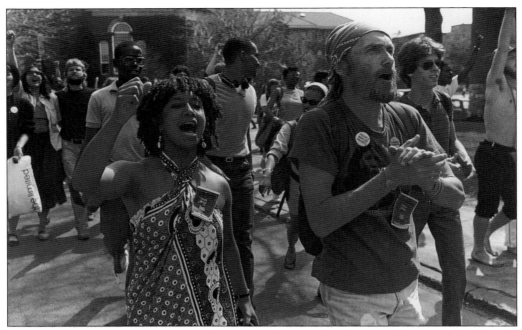

Starting in the late 1970s, as part of a larger movement against South African apartheid, American colleges and universities started pressuring their boards to sell stock in corporations doing business in South Africa. As depicted in this 1985 photograph, Syracuse University students protested and demanded the board of trustees divest the university's South African financial interests. They hammered wooden crosses into the ground and camped outside the Administration Building.

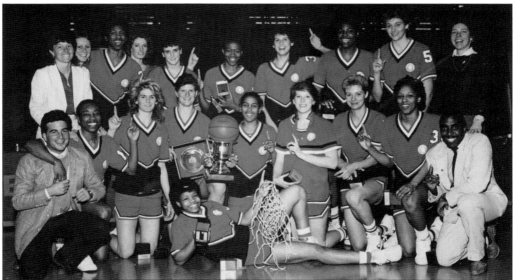

The Syracuse University women's basketball team played its first season in the Big East Conference in 1982. In the Big East tournament final in 1985, with seconds left on the clock, the team captain shot the ball, which found its way into the basket at the buzzer, capturing the Orangewomen's first-ever title with a one-point victory over rival Villanova University.

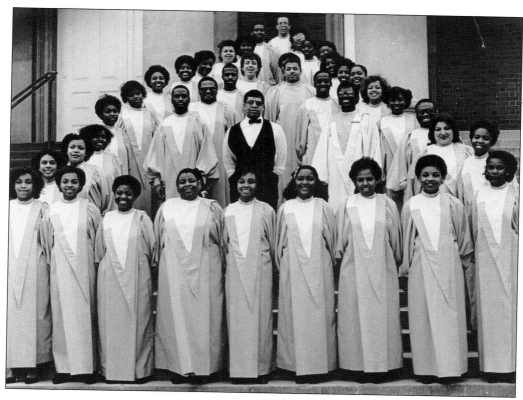

The Black Celestial Choral Ensemble, shown here in 1982, is a gospel choir founded by seven students in 1977. Strengthening ties between the city and the university, the ensemble has performed at various events both on campus and in the Syracuse community. Mixing traditional and contemporary gospel music and bringing a spiritual message to audiences, the choir has sung at schools and churches throughout the Northeast.

In 1969, Syracuse University established a childcare center on South Campus for the children of university families. In 1986, the original prefabricated, World War II–era building was demolished, and a new center was built. Here, Chancellor Melvin Eggers begins the renovation project at the ground-breaking ceremony with help from the center's clients.

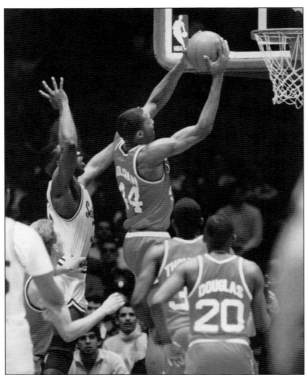

The 1986–1987 Syracuse University men's basketball season was the best the Orangemen had played up to that time. A superior lineup led them to the Final Four at the Superdome in New Orleans. The final, against Indiana University, stayed even for the entire game until, with seconds left and a Syracuse 73-72 lead, Indiana sank a jump shot. Syracuse lost by one point. The Syracuse newspapers mourned: "SO CLOSE."

Starting in the mid-1980s, the annual Martin Luther King Jr. Dinner has grown to become one of the largest celebrations of Dr. King's legacy on a university campus. Each year, the Syracuse community gathers for a sit-down dinner (for more than 2,000), a festive program, and presentations of Unsung Hero Awards. Featured keynote speakers in the past have included Harry Belafonte, Andrew Young, and Suzan-Lori Parks.

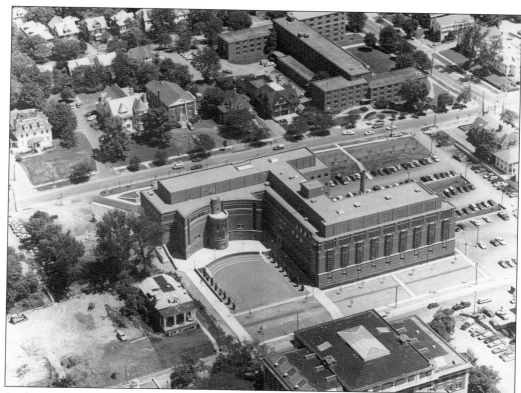

Dedicated in 1989, the Center for Science and Technology houses the Center for Advanced Systems and Engineering (CASE). It also includes educational facilities in computer science, electrical and computer engineering, information studies, and chemistry. With the establishment of the CASE Center and the construction of the Center for Science and Technology, Chancellor Eggers declared that the university's goal for a "tier of excellence . . . has been achieved."

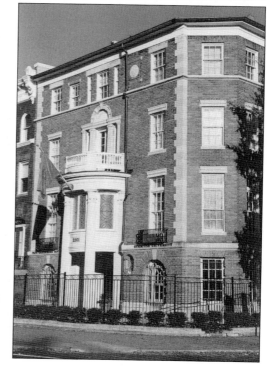

In 1988, trustee Paul Greenberg (class of 1965) contributed toward the purchase and renovation of this 1912 Beaux-Arts Classical house in Washington, DC. Greenberg House is similar in function to New York City's Lubin House. It is the site of academic functions, alumni activities, student recruitment, and university development. It also serves as the site of seminars and internships for the Maxwell School.

On December 21, 1988, a terrorist bomb took down Pan Am Flight 103 over Lockerbie, Scotland, killing all 259 passengers and crew as well as 11 people on the ground. Included among the 270 victims were 35 students studying abroad with Syracuse University. Reeling from the loss of what the chancellor referred to as "the best and the brightest," the university held a memorial service in the Carrier Dome on January 18, 1989 (above). Over 14,000 attended, including families of most Syracuse University victims, the governor, and both New York senators. At that service, Syracuse promised to construct a permanent memorial. On April 22, 1990, the university dedicated the Place of Remembrance (below), a semicircular structure inscribed with the names of the 35 students. A circular stone bench honoring a local couple who were also killed is part of the memorial.

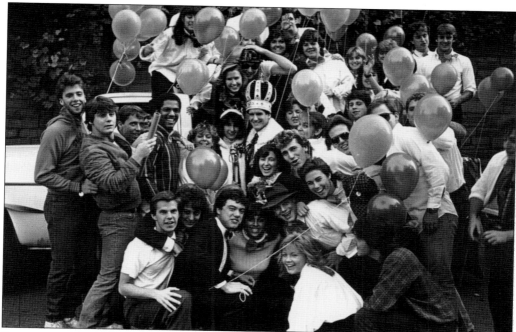

Syracuse University's Homecoming
Queen and King stand with a crowd
of students in the 1980s. Even
though Homecoming Weekend saw
its heyday in the 1950s and 1960s, it
remains a strong Syracuse tradition
for students and alumni. In the 1980s,
the weekend included a parade
with floats and the marching band,
alumni dinners, a pep rally, the
crowning of the king and queen, and
a big football game.

Dorothea Ilgen Shaffer and her
husband, Maurice, donated funds
for a new art building, which was
completed in 1990. It was constructed
to house the two-dimensional
arts, including advertising design,
communication design, computer
graphics, drawing and painting,
fashion illustration, film, the
Freshman Foundation Program,
museum studies, photography, and
video. The Shaffer Art Building
includes studio space, a 60-seat
lecture hall, a 300-seat auditorium,
lounge and gallery space, and offices.

Kenneth A. Shaw was the 10th chancellor of Syracuse University, serving between 1991 and 2004. Formerly president of the University of Wisconsin System and chancellor of the Southern Illinois University System, Shaw restructured Syracuse University, stabilized its financial situation, and led a successful "Commitment to Learning" campaign that raised over $370 million. In 1997, he was elected chair of the NCAA Division I Board of Directors. Affectionately called "Buzz," Shaw was accessible to students. His vision for Syracuse University encompassed making it the nation's leading "student-centered university," which encompassed improving faculty roles and rewards to help create a better learning and student-centered culture. Shaw wanted the university to be "a place where scholarship and discovery is valued and supported . . . combining it with an equal emphasis on the value of teaching and learning."

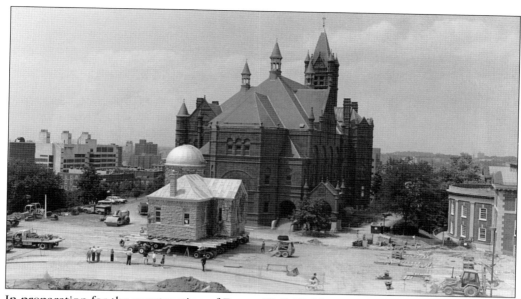

In preparation for the construction of Eggers Hall, Holden Observatory, the second-oldest building on campus, was moved 180 feet to the southwest in June 1991. It took three days to move the 375-ton observatory on 20 hydraulic dollies. As Holden is a designated national landmark, the university had to ensure that the move would not alter the building's physical structure.

Named for former chancellor and economics professor Melvin A. Eggers, the six-story Eggers Hall is linked to Maxwell Hall by a three-tiered atrium. It houses departments of the Maxwell School, including history, economics, political science, and geography. Seminar rooms in Eggers Hall honor the Seneca Falls Women's Movement and the Onondaga Nation.

The Mary Ann Shaw Center for Public and Community Service (CPCS) opened in 1994. Although community service was long a part of the university, the chancellor's wife, Mary Ann Shaw, shown here in 1994 with current trustee Joshua Heintz (class of 1969), took the lead in bringing myriad independent projects under one umbrella. Today, hundreds of student volunteers clock thousands of hours of literacy work and service learning through CPCS.

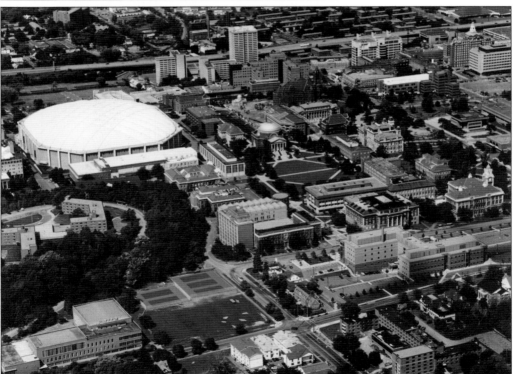

By the end of the 20th century, the campus began to look much as it does today. Buildings including the Carrier Dome, Crouse-Hinds Hall, Barclay Law Library, Schine Student Center, Center for Science and Technology, Shaffer Art Building, and Eggers Hall were constructed. By 1999, Syracuse had a faculty of nearly 1,400, over 3,000 staff, and a total enrollment of 18,556, representing 50 states and more than 90 countries.

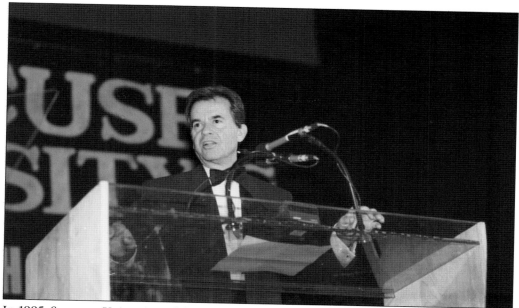

In 1995, Syracuse University celebrated its 125th anniversary. Since the 75th anniversary fell during World War II and the 100th during the student unrest of 1970, the university was ready for a major celebration. The yearlong event featured a rededication of the Maxwell-Eggers complex, the first National Orange Day, and a gala dinner in the Carrier Dome, with alumnus Dick Clark (class of 1951) serving as master of ceremonies.

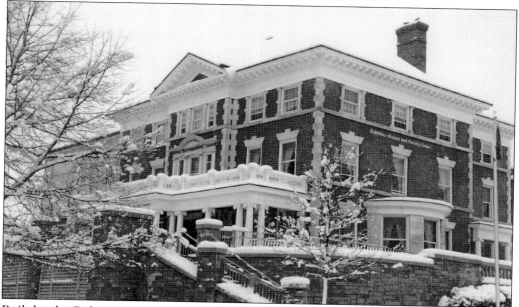

Built by the Delta Kappa Epsilon fraternity as a chapter house in 1903, this Federal-style residence was purchased by the university in 1974 and remodeled into a faculty center. In the spring of 1996, plans for the expanded Goldstein Alumni and Faculty Center were announced. Renovated and reopened in August 1997, the center has kitchen facilities, dining rooms and bar, meeting rooms, and the Syracuse University Alumni Relations Office.

In 1978, members of a Native American student organization protested against the Saltine Warrior and successfully petitioned the university to stop using it as Syracuse University's mascot. A search for a successor then began. Briefly in 1978, a Roman gladiator made appearances in Archbold Stadium, but he was unpopular and was booed off the field. Several other candidates were considered, including a penguin with an orange scarf, an orangutan, the "Dome Ranger," the "Abominable Orangeman," and Egnaro the Troll. But it was a fuzzy, lovable orange that grew in popularity. First introduced in 1980, the mascot was known as "the Orange" until 1990, when the cheerleaders started calling it "Otto." In February 1995, Chancellor Shaw appointed a committee of students, faculty, and staff to recommend a mascot. In the fall, the committee recommended adopting a wolf as the university mascot, but students campaigned for the Orange. In early December, Chancellor Shaw, recognizing its popularity on and off campus, named Otto as the official Syracuse University mascot. The Otto shown here is from 1982.

Seven

THE SOUL OF
SYRACUSE UNIVERSITY

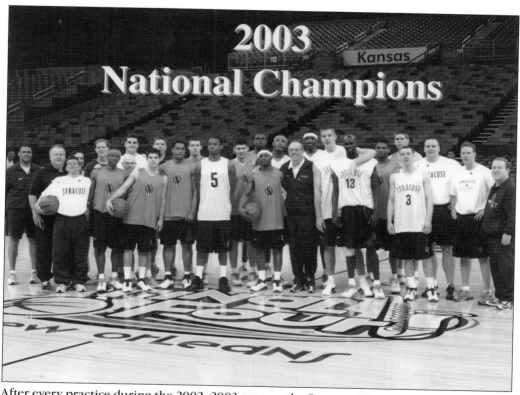

After every practice during the 2002–2003 season, the Syracuse University men's basketball players would gather as a group, put their hands together, and shout in unison, "Final Four!" On April 7, 2003, that is where the team found itself—in the New Orleans Superdome, celebrating Syracuse University's first NCAA Division I basketball championship. The April 8, 2003, *Daily Orange* headline is a triumphant "AT LAST!"

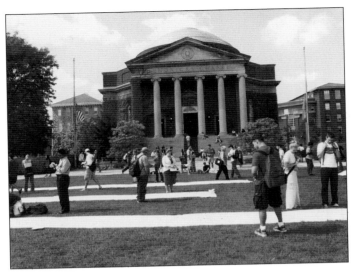

After the terrorist attacks of September 11, 2001, members of the Syracuse University community came together. Students gathered in places like Hendricks Chapel and residence halls to support each other. In the following days, the Student Association placed "Sheets of Expression" on the Quad. Students, faculty, and staff wrote their thoughts, fears, and prayers and drew symbols of peace, hope, and patriotism on sheets laid out on the grass.

In 2001, three colleges merged into the College of Human Services and Health Professions. A tree was planted on the Quad to represent how the School of Social Work, College of Nursing, and part of the College for Human Development had become one. In 2011, the college added sport management and became the David B. Falk College of Sport and Human Dynamics.

Nancy Cantor became the 11th and first woman chancellor of Syracuse University in 2004. She was formerly chancellor of the University of Illinois at Urbana-Champaign and professor of psychology. Cantor's theme for her inaugural year was "Exploring the Soul of Syracuse." She invited members of the university and central New York community to engage in conversation and collaborate around this idea.

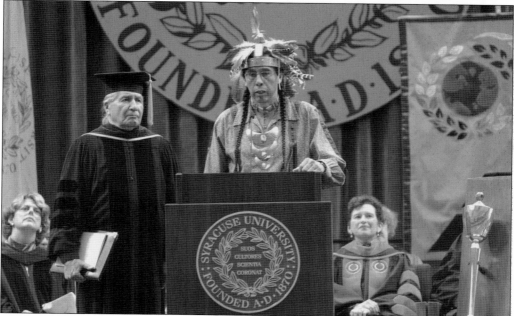

Tadodaho Sid Hill (at podium) and Faith Keeper Oren Lyons welcomed Chancellor Nancy Cantor to campus at her inauguration in the Carrier Dome on November 5, 2004. The previous August, the university and the Haudenosaunee (Iroquois) communities jointly announced the "Haudenosaunee Promise" program to offer full scholarships to qualified students from the Six Nations, thus honoring and expanding the historical and cultural relationship between the university and the Haudenosaunee.

For more than 50 years, Delta Kappa Epsilon brothers played the Crouse College chimes, which were donated by John Crouse in 1889. The responsibility was passed on to music fraternities and then to a group of students called the Chimemasters. Like this student in 2005, they climb a 70-foot ladder into the tower to play anything from the university's fight song to contemporary tunes for all of campus to hear.

A number of new academic and community-based programs were established in the 2000s. Among these programs are the following: the Bandier Program for Music and the Entertainment Industries; the Institute for Justice, Politics, and the Media; the Institute for National Security and Counterterrorism; a neighborhood revitalization program called the Near Westside Initiative; and the South Side Innovation Center entrepreneurship program. Shown here in 2005 is the inaugural class of the Goldring Arts Journalism program.

First occupied in 1983 and originally built as the Crouse-Hinds School of Management Building, Crouse-Hinds Hall holds classrooms, offices, and a 200-seat auditorium. In 2005, the Whitman School of Management moved into a new building, and the repurposed Crouse-Hinds Hall became home to offices such as Academic Affairs, the Chancellor's Office, the Admissions Office, the Board of Trustees Office, the Burton Blatt Institute, and the Provost's Office.

One of the most famous numbers in college football history—44—was retired by Syracuse University on November 12, 2005. The uniform number was made famous by such players as professional and college football hall of famer Jim Brown, Heisman Trophy winner Ernie Davis, and three-time All-American Floyd Little. These three players led the Orange to 65 victories, earned six first team All-American honors, and participated in five bowl games.

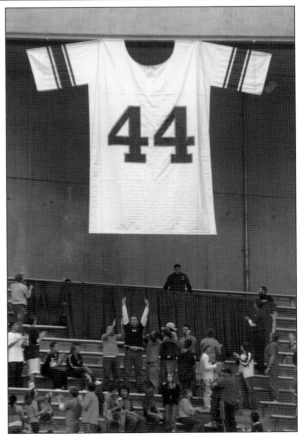

The Martin J. Whitman School of Management's new building became the school's new home in 2005. The structure includes a three-story, 4,000-square-foot grand hall, 22 classrooms, 40 team rooms, a 200-seat auditorium, two computer clusters, 70 faculty offices, and an investment research center. Partly constructed of recycled materials, the building features environmentally friendly roofing and heating.

Students show off their hard work during Mayfest in 2008. First organized in 2005, Mayfest was a university celebration of students' creative and innovative academic work. Presentations, demonstrations, and performances took place all over campus. Members of the university and larger communities, including local high school students, have attended the event. In 2009, Mayfest was renamed SU Showcase.

The Burton Blatt Institute (BBI) promotes global efforts to advance the civic, economic, and social participation of people with disabilities. Building on the legacy of Burton Blatt, pioneering disability rights scholar, the BBI has offices in Syracuse, Washington, DC, and Atlanta. From left to right, columnist George Will, former New York governor Hugh Carey, Chancellor Nancy Cantor, and BBI chairman Peter Blanck gather in New York City for the 2006 inaugural breakfast.

In the spring of 2005, Syracuse University began expanding into the downtown area and renovated a former furniture warehouse near Armory Square. This was done to enhance the natural connection between the university and the city. The Warehouse has office space, classrooms for art education, and a community art wing. It is also an international contemporary art venue of SUArt Galleries of Syracuse University.

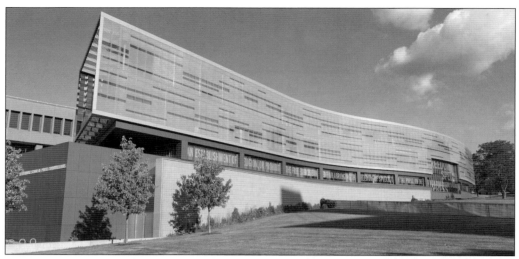

In September 2007, the dedication of Newhouse Communications Center III completed trustee Samuel I. Newhouse's plan of a trio of buildings dedicated to journalism in all its forms. Newhouse III features a collaborative media room, a 350-seat auditorium, and a café. The *Liberty Wrap* features the words of the First Amendment etched in six-foot-high letters on the glass facade of the building.

Established in 2005, the Connective Corridor builds upon the symbiotic relationship between the university and the city of Syracuse. The corridor, which physically links more than 30 arts, cultural, and educational venues, is emerging as a signature strip of cutting-edge cultural development. Buses connect the university and downtown venues, including the Warehouse, Armory Square, and Near Westside, central business districts, and neighborhoods undergoing extensive revitalization. (Photograph by Eric Persons.)

In June 2007, Hollywood came to Syracuse to film scenes for the movie *The Express*. Actor Rob Brown, who plays Syracuse's Heisman Trophy winner Ernie Davis in the film, met with coach Ben Schwartzwalder's widow, Reggie (right), and granddaughter Felicia Walker (center), who were film extras. To coincide with the movie's world premiere in the city of Syracuse, the university unveiled a statue of Davis and named a new dormitory for him.

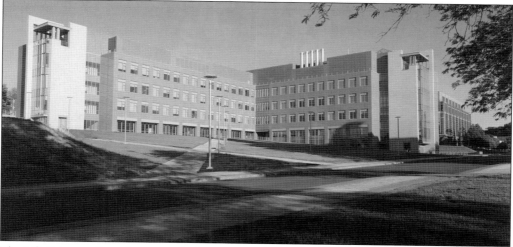

The Life Sciences Complex, occupied in 2008, brought the biology, chemistry, and biochemistry departments under one roof for the first time in the university's history. The five-story building forms an L-shape configuration, with a research wing and a teaching wing. An atrium, with a café, connects the Life Sciences Complex to the Center for Science and Technology.

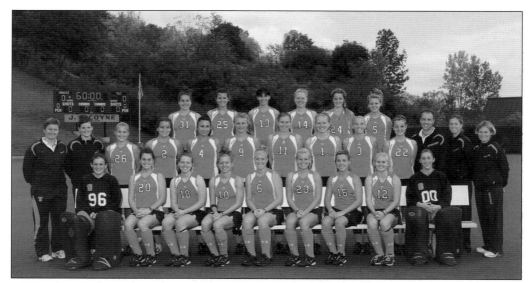

Having moved to NCAA Division I in 1982, Syracuse University's field hockey team has consistently proved its mettle. In the 2008 Big East championship final, the team earned a penalty corner before regulation time expired. With the score against Connecticut 0-0 and no time remaining, Syracuse scored the goal that resulted in a thrilling 1-0 victory, the Big East championship, and a first Final Four appearance in the NCAA tournament.

The Syracuse chapter of Say Yes to Education, a national program implemented through the School of Education, offers opportunities to urban youth. The Say Yes promise begins when a child enters kindergarten and continues through high school and beyond, rewarding effort with a college education. In 2011, Taye Diggs (class of 1993, right) and Shane Evans (class of 1993) read their children's book to Syracuse city students during a Say Yes to Education event.

Opened in 2009, the Carmelo K. Anthony Basketball Center, a versatile, state-of-the-art facility, is part of the Lampe Athletic Complex. The 54,000-square-foot, Leadership in Energy and Environmental Design–certified building contains two practice courts, a weight room, a locker room, offices, and trophy rooms. There is also a Hall of Fame room, where the 2003 national championship trophy, won with the considerable talents of donor Carmelo Anthony, resides.

Syracuse University established a presence in Los Angeles in 2005 to provide a range of social and educational activities for alumni and students. In keeping with Chancellor Cantor's vision of "Scholarship in Action," the L.A. Center engages alumni experts in supporting academic programs. Students participating in the L.A. Semester program take classes and internships in their chosen fields. In 2009, alumnus Aaron Sorkin (class of 1983, center) hosted incoming L.A. Semester students.

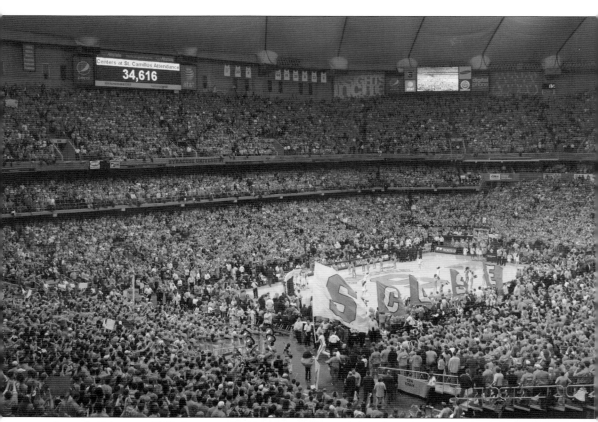

In early February 2010, Syracuse University announced that the February 27 matchup between its third-ranked men's basketball team and longtime rival Villanova University at the Carrier Dome was sold out. A grand total of 34,616 tickets had been sold. Syracuse University students had brought out their camping gear a week ahead of time to hunker down at the box office in order to secure good seats, and prices for tickets on eBay had rocketed to over $1,000 each. Carrier Dome seating had to be extended to accommodate the unexpected surge in spectator numbers. The game shattered the Dome attendance record and, in turn, set a new NCAA on-campus attendance record. The previous record of 33,633 had been a losing game against Villanova on March 5, 2006. As the top-selling fan T-shirt proclaims, "Just Me and 34,616 of My Friends—BEAT 'NOVA." The Syracuse team did just that, by a score of 95-77.

On December 30, 2010, the inaugural New Era Pinstripe Bowl was played in Yankee Stadium in front of 38,274 fans. The Syracuse University football team, under coach Doug Marrone, was able to keep up with Kansas State University and claim a 36-34 victory. It was the first bowl game win for Syracuse football since 2001.

In 2002, one of the New York State–sponsored Centers of Excellence was established at Syracuse University. Opened in 2010, the five-story Syracuse Center of Excellence in Environmental and Energy Systems building (called "SyracuseCoE") houses offices, classrooms, public spaces, and laboratories. The facilities are used by a worldwide network of academic and industry collaborators for research, primarily in the areas of indoor environmental quality, clean energy, and energy efficiency.

International education at Syracuse dates back to 1919, when students first went to Chungking, China. The Syracuse in Florence program opened in 1959 and Syracuse in London in 1971. Since that time, students from Syracuse and other colleges have chosen to study abroad at many locations, including overseas centers in Hong Kong, Istanbul, Madrid, Santiago (Chile), Strasbourg (France), and in Beijing, shown here in 2010.

Drawing upon a history of military tradition and a partnership with veterans on campus, in 2011, Syracuse University established the Institute for Veterans and Military Families in University College, a first in higher education. The institute offers education and employment-focused programs, collaborating with industry, government, organizations, and the veteran community. It addresses the economic and public policy concerns of the nation's servicemen and servicewomen and their families.

Syracuse University began National Orange Day on March 24, 1995. In commemoration of the university's Founders Day, alumni around the world have shown their orange pride by sporting the color orange on the university's birthday. Organized by the Syracuse University Alumni Association and the Student Association, the day also has been spent in service-oriented activities such as Community Cleanup Day, a cake-cutting ceremony, contests, and, as here, posing with Otto.

Chancellor Cantor and Senior Vice Pres. and Dean of Student Affairs Thomas Wolfe welcome incoming first-year students at the 2012 Chancellor's Convocation for New Students and Lunch on the Turf in the Carrier Dome. Throughout her tenure, Cantor has expressed her vision for the university as "Scholarship in Action," a commitment to forging bold, imaginative, reciprocal, and sustained engagements with the university's many constituent communities, local as well as global.

Students proudly pose next to a snowman they built on the Quad in front of Link Hall in January 2003. Regarded as the snowiest large city in the United States, Syracuse averages over 115 inches of snow a year (that's over nine feet!). Throughout Syracuse University's history, its students have had to find ways to cope—and enjoy—the winters. The campus has rarely closed for bad weather, so students have trudged through snow many mornings on their way to class, struggled to find parking among the snowbanks, and shivered while waiting at bus stops. They survived blizzards in 1966 and 1993 and learned to have winter coats and boots handy before Thanksgiving break. But students also have competed in snow sculpture contests during Winter Carnival, skied on snowy slopes on South Campus, ice-skated out in Drumlins, and sledded down Crouse Hill on cafeteria trays.

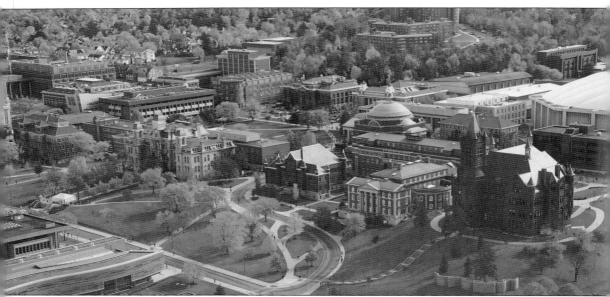

Since its founding in 1870, Syracuse University has embodied "Scholarship in Action," offering an education that transcends traditional boundaries through innovative thinking, daring choices, and entrepreneurial attitude. The campus in central New York has grown over the past 140 years, but the historical roots of the university remain. By the late 2000s, original buildings such as the Hall of Languages and Crouse College still proudly stand along the Old Row. The long-hoped-for completion of the Newhouse Complex occurred in 2007 with the building of Newhouse III. In 2008, the Life Sciences Complex and an addition to Link Hall, known as Link+, created new homes for science and technology. As Syracuse University looks toward its 150th anniversary in 2020, the campus continues to transform and expand with new facilities to meet the needs of future generations of students.

DISCOVER THOUSANDS OF LOCAL HISTORY BOOKS FEATURING MILLIONS OF VINTAGE IMAGES

Arcadia Publishing, the leading local history publisher in the United States, is committed to making history accessible and meaningful through publishing books that celebrate and preserve the heritage of America's people and places.

Find more books like this at
www.arcadiapublishing.com

Search for your hometown history, your old stomping grounds, and even your favorite sports team.